IMAGES
of America

DOWNTOWN PITTSBURGH

IMAGES
of America

DOWNTOWN PITTSBURGH

Stuart P. Boehmig

ARCADIA
PUBLISHING

Published by Arcadia Publishing
Charleston, South Carolina

Printed in the United States of America

Library of Congress Catalog Card Number: 2007922534

For all general information contact Arcadia Publishing at:
Telephone 843-853-2070
Fax 843-853-0044
E-mail sales@arcadiapublishing.com
For customer service and orders:
Toll-Free 1-888-313-2665

Visit us on the Internet at www.arcadiapublishing.com

To Jason and Cody.

CONTENTS

ACKNOWLEDGMENTS

I want to thank the people who look after the archives of the history of Pittsburgh, including Gil Pietrzak of the Carnegie Library of Pittsburgh, Miriam Meislik of the Archive Service Center of the University of Pittsburgh, Brooke Sansosti of the Carnegie Museum of Art, and Lauren Zablelsky of the Historical Society of Western Pennsylvania, all of whom kindly helped me with this project. The images in this volume are drawn from the collections of the Carnegie Library of Pittsburgh, Archives Service Center of the University of Pittsburgh, Historical Society of Western Pennsylvania, and Carnegie Museum of Art.

INTRODUCTION

When 21-year-old Maj. George Washington of the Virginia Militia first set foot on the land known as the Forks of the Ohio in the fall of 1753, there was no city—not even a small village or a single log cabin. This 300-acre triangle of land, hemmed in by the junction of the Allegheny and Monongahela Rivers, was a frontier wilderness. The territory surrounding "the Forks" was a place of wild bears, cougars, bison, mountain lions, badgers, and beavers. At the time, there was no name for the Allegheny River. It was considered a branch of the upper Ohio River.

Before Washington arrived, Native Americans had foraged the area for 10,000 years following the retreat of the glaciers during the Wisconsin ice age. But it was the powerful Iroquois Confederacy that first settled the region. This loosely formed Iroquois Nation, representing the Seneca, Shawnee, Tuscarora, Cayuga, Oneida, Mohawk, Huron, Mahican and Delaware tribes, referred to themselves as "all one people." They came to the region after giving up their territory in eastern New York and Pennsylvania to the heirs of William Penn and other English landowners who were buying and settling their land. Because they saw no significance in the triangle of land at the confluence of the rivers, they traveled through the area but never established a settlement at the Forks. At the time, the Forks were largely ignored. It was the rivers, not the land, that were important. The rivers were the arteries of an expanding network of trade, travel, and communication.

It was not until 1749 that the French recognized that control of the Forks would give them command over much of North America. The governor general of Canada, the Marquis de La Galissoniére, sent Capt. Pierre-Joseph Celeron de Blainville with 230 French soldiers, 180 Canadians, and a band of Native Americans down the Allegheny and Ohio Rivers to claim possession of the valley for King Louis XV of France. He buried engraved lead plates at various points to mark the land for France. Celeron floated past the site of Pittsburgh without realizing its significance or even taking note of its strategic importance. When he returned to Montreal, Celeron reported of the Native Americans, "All I can say is that the nations of these localities are badly disposed toward the French, and are entirely devoted to the English."

Washington passed through the Forks on November 24, 1753, with his frontier guide Christopher Gist, a neighbor of Daniel Boone. He was commissioned to deliver a handwritten message from Gov. Robert Dinwiddie of Williamsburg, Virginia, to the French commandant at Fort Le Bouef near Lake Erie. The letter demanded that the French concede North America to the British Empire. Washington reached Fort Le Bouef on December 10, 1753. The French commandant quickly rejected Dinwiddie's letter. His rebuff set the French on a collision course with the British Empire for control of land at the Forks and for all of North America. In Europe, it marked the beginning of the Seven Years War between the French and English empires.

With the French rejection, Washington immediately began the hazardous journey back to Virginia in the middle of a harsh and bleak winter. When he passed through Venango (Franklin), he left his weakened horse and tired companions and struck out on foot with Gist. Along the way, Washington was nearly shot by a Native American allied with the French, and on December 30, 1754, he and Gist almost drowned in the icy waters of the Allegheny River near present-day Lawrenceville after their raft had been dashed to pieces by floating ice.

Little did the young Washington know that one day this swath of frontier land he knew as the Forks of the Ohio would become the heart of the great Industrial Revolution. The Allegheny Mountains, the western part of the Appalachian Mountains, were brimming with undiscovered oil, bituminous coal, salt, silicon, limestone, clay, and iron. In less than 100 years, immigrants arrived from Germany, Ireland, Scotland, and England and later from central Europe, Poland, Lithuania, Czechoslovakia, Serbia, and Italy. They signed contracts in their homeland to pay for passage to the New World. In return they worked in the glass, iron, and steel mills that fueled the growth of America.

First the trappers and traders would come. The earliest white man to travel down the river past the Forks was Arnold Viele, a Dutch trader from Albany, New York, in 1692. He was followed by frontier mountain men, including Thomas Cresap, George Croghan, Barney Curran, John Fraser, William Trent, Alexander McKee, James O'Hara, Jonas Davenport, and Christopher Gist (Washington's steadfast guide). The trappers and traders were followed by the soldiers of the French and English empires.

Their armies would collide in a fiercely fought conflict for control of the Forks, which at the time was the most strategic piece of land in North America. When the English finally prevailed, the Forks once again became largely neglected and ignored. Arthur Lee of Virginia noted the insignificance of the Forks in 1763 when he wrote, "The town (Pittsburgh) is inhabited almost entirely by Scots and Irish, who live in paltry log houses and are as dirty as in the north of Ireland, or even Scotland. There are, in the town, four attorneys, two doctors, and not a priest of any persuasion, nor church nor chapel: so that they are likely to be demanded without the benefit of clergy. The place, I believe will never be considerable." At the time Lee did not realize that this triangle of land, along with the natural resources waiting to be discovered at the confluence of the two rivers, would become known as the Workplace of the World.

This is the story of downtown Pittsburgh, a city bounded by two rivers and a steep bluff to its east, which formed a natural 300-acre triangle of land. The Seneca Indians were the first to name the area. They said, "the land at Diondega." Diondega simply meant "the Forks." This is the story of how this small wedge of flat bottomland became the place where history was changed and America was built.

One

THE FORKS OF THE OHIO

In the fall of 1753, British governor Robert Dinwiddie of Williamsburg, Virginia, dispatched 21-year-old Maj. George Washington and a small group of militia to travel through the Allegheny Mountains to the Forks of the Ohio (Pittsburgh), then to Venango (Franklin) and finally up French Creek to Fort Le Bouef near Lake Erie. His mission was to demand the French commandant Legardeur de St. Pierre to leave the Ohio Territory and all of North America to the British. Washington arrived on December 10, 1753. St. Pierre quickly rejected Dinwiddie's request, "I do not think myself obliged to obey." Washington, realizing the urgency of the situation, wrote Dinwiddie, "The French are now coming from their Forts on and near the Lake Erie to Venango [Franklin] to erect another fort and from thence they design to the Forks of the Monongahela [Pittsburgh] and to the Logs Town [Ambridge] and to continue down the River Building at the most convenient places in order to prevent our Settlements." (Carnegie Library of Pittsburgh.)

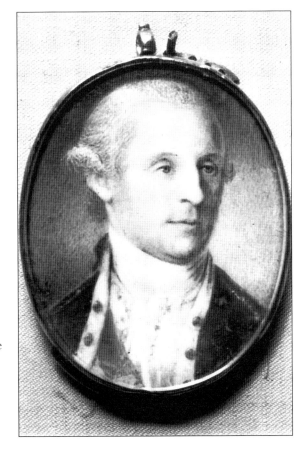

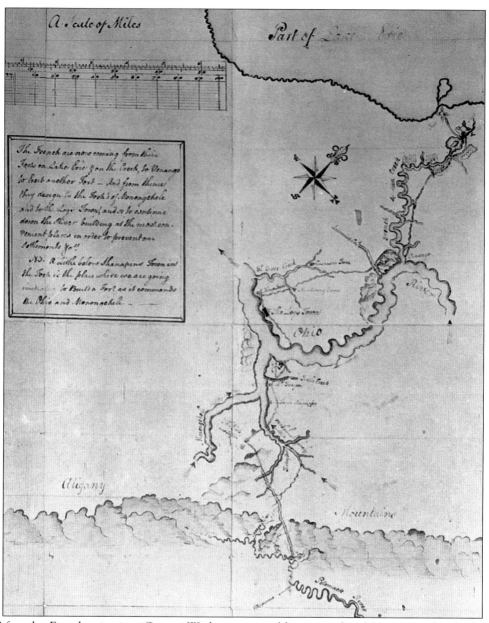

After the French rejection, George Washington quickly returned to Virginia in the dead of winter with his guide Christopher Gist. On the way, he was nearly shot by a Native American and almost drowned in the Allegheny River near Shannopin Town (Lawrenceville). Washington drew a map for Gov. Robert Dinwiddie of his journey to Fort Le Bouef (above). Logstown (Ambridge) and Shannopin Town, the only settlements in the area of "the Forks," are identified on the map. At the time, the French and Native Americans considered the Allegheny and Ohio Rivers to be one river called La Belle Riviere (the Beautiful River). Washington described the land at the Forks as "extremely well situated for a Fort; as it has the absolute Command of both rivers. The Land at the Point is 20 or 25 Feet above the Common Surface of the Water; and a considerable Bottom of flat land, well timbered Land all around it for very convenient Building." (Carnegie Library of Pittsburgh.)

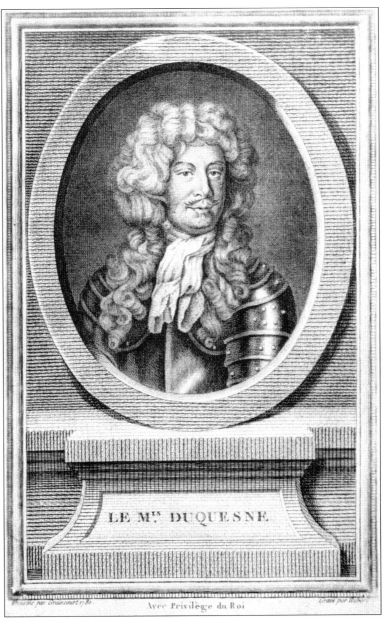

LE M. DUQUESNE

Avec Privilège du Roi

The English began construction of the first fort at the Forks on February 17, 1754, when British captain William Trent and 40 men sent by Dinwiddie of Williamsburg, Virginia, arrived to convert a small Ohio Company trading post into a military fortification. The stockade they built was the first settlement at the Forks. Trent named it Fort Prince George. When Trent left for Maryland to gather needed supplies, he left Ens. Edward Ward in charge of the inadequate fort. On April 13, 1754, Ward learned French troops were on the march against him and immediately began to build a larger, stronger fort made of log parapets. He named it Trent's Fort. When French captain Sieur de Contrecoeur arrived, he surrounded the fort and demanded immediate surrender. Ward was hopelessly outnumbered and turned over the fort and its 600 soldiers. The French quickly dismantled the flimsy stockade and built Fort Duquesne in honor of New France governor general Marquis de Duquesne (pictured here). (Carnegie Library of Pittsburgh.)

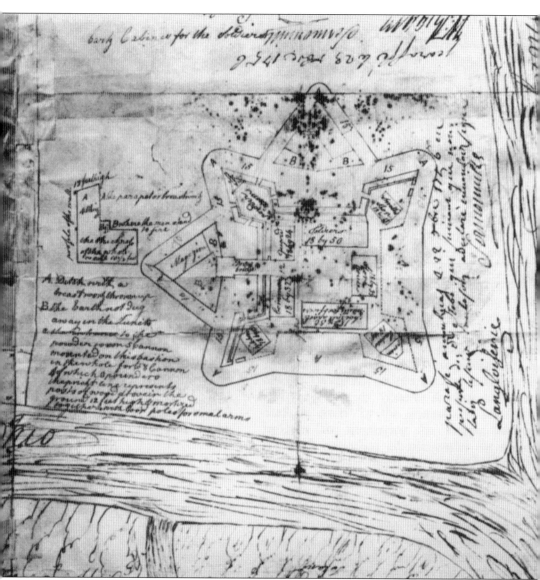

On April 21, 1754, George Washington left Virginia with two companies of militia to take hold of the Forks. The French were warned of his approach and attacked him at Fort Necessity (near Uniontown) on July 4, 1754, killing over 100 soldiers. The French took two prisoners, Jacob Van Braam and Scotsman Robert Stobo, to Fort Duquesne. Stobo kept a diary, and on July 28, 1754, he smuggled out a letter to British commander James Innes through a friendly Native American named Delaware George. Stobo enclosed an accurate sketch of the fort (above). He wrote, "I would die a thousand deaths, to have the pleasure of possessing this Fort one day. They [the French] are so vain of their success at the Meadows [Fort Necessity] it is worse than death to hear." The following day he sent another letter with Delaware George stating, "Haste to strike." The British would not return until four years later. (Historical Society of Western Pennsylvania.)

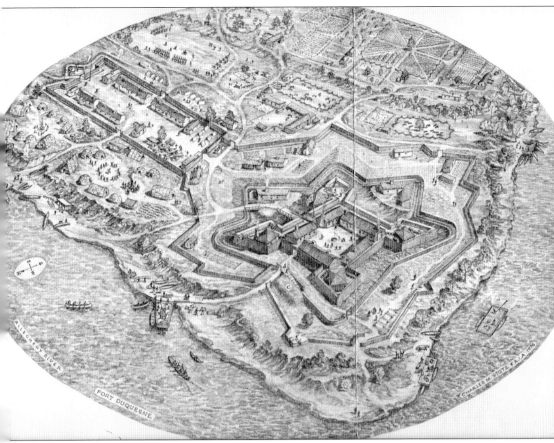

On May 24, 1755, the French completed Fort Duquesne, including a commandant's house, officer quarters, barracks, kitchen, powder magazine, and blacksmith's shop. Ramparts were constructed of earth packed between two horizontal log walls 12 feet wide that were designed to withstand light artillery fire. There was a port on the Allegheny River, a Native American village, and a parade ground outside the fort. On July 9, 1755, British general Edward Braddock attempted to take Fort Duquesne with 1,460 elite Cold Stream Guards from Scotland. Braddock's troops were ambushed on a wilderness road six miles from the fort (near present-day Turtle Creek). In two hours of fierce fighting, 456 of his men were killed and 421 wounded. Braddock died of wounds three days later. His aide, Washington, did the eulogy, buried him in the road, and had the army march over the grave to hide it from Native Americans. Modern-day architect Charles Stotz drew an illustration of what Fort Duquesne would have looked like in 1775 (above). (Historical Society of Western Pennsylvania.)

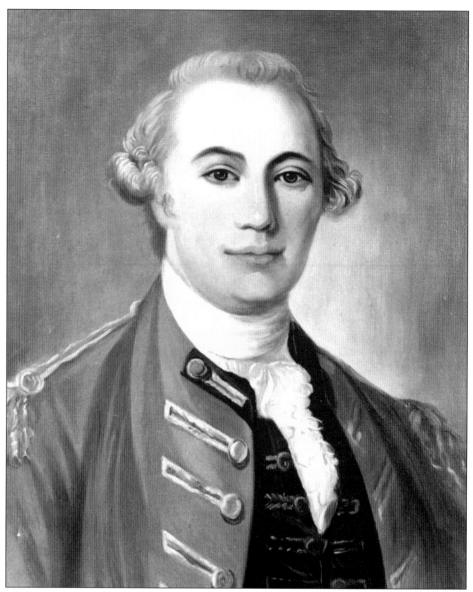

Nearly four years later, British forces returned with 10,000 soldiers led by Gen. John Forbes (pictured here). On September 7, 1758, Forbes sent Maj. James Grant, with 800 soldiers of the 77th Highland Scottish Regiment, to reconnoiter Fort Duquesne. From the bluffs overlooking the fort (Duquesne University), Scottish bagpipes played as Grant recklessly sent 100 Highlanders to attack. Nearly 800 French and Native Americans poured out of the fort and surrounded the charging forces. Grant rushed into the battle, but by 11:00 a.m., he was routed with more than half his men killed or wounded. Forbes decided to delay a further attack until spring, but George Washington captured several Native Americans who told him the fort was dangerously undermanned. Forbes ordered an immediate advance. On November 24, 1758, the French, fearing the attack, abandoned the fort under the cover of night, set it on fire, and withdrew down the Ohio River. Forbes arrived the next day and took possession of the smoldering remains. Inside he found the heads of Grant's Highlanders impaled on stakes. (Carnegie Library of Pittsburgh.)

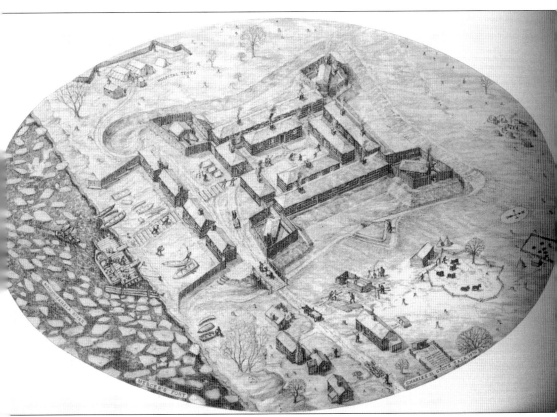

On November 25, 1758, the English flag flew over the Forks and the Ohio River Valley for the first time. After four years of French supremacy, the British were now in control. Forbes's army camped at the charred remains of Fort Duquesne without adequate food, clothing, or shelter to survive the harsh and unforgiving frontier winter. On November 26, the soldiers knelt for the observance of Thanksgiving. They called their camp Fort Argyle. Several days later, Grant's soldiers buried the bodies of their slain comrades. When Forbes returned to Philadelphia for supplies, he left a skeleton force with Col. Hugh Mercer. It was the dead of winter, and the British army was more than 300 miles from help or aid. Mercer, a Scottish physician, constructed Fort Mercer along the Allegheny River to provide protection and shelter for his troops during the approaching winter. (Historical Society of Western Pennsylvania.)

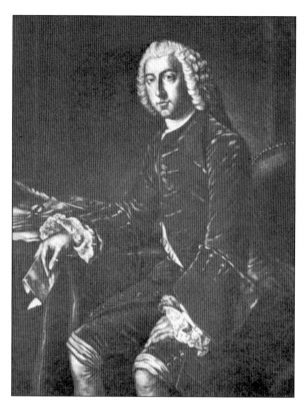

On November 25, 1758, Gen. John Forbes named Pittsburgh. He wrote a dispatch to his superiors beginning, "Fort Duquesne now Pittsburg." He later wrote the prime minister of England, William Pitt (pictured here), "[I have] used the freedom of giving your name to Fort Duquesne, as it was in some measure being activated by your spirits that now make us masters of the place." Three months later, Forbes died of illness. (Carnegie Library of Pittsburgh.)

In 1756, Col. Henry Bouquet arrived from Switzerland to command the Royal American Regiment. His commission was to recruit the German-speaking population of the country. At the time, 55 percent of the population came from England, Scotland, and Ireland, and 20 percent came from Germany. The remainder of his army was from central Europe. In 1764, he built the blockhouse at Fort Pitt, now the oldest remaining building in Pittsburgh. (Carnegie Library of Pittsburgh.)

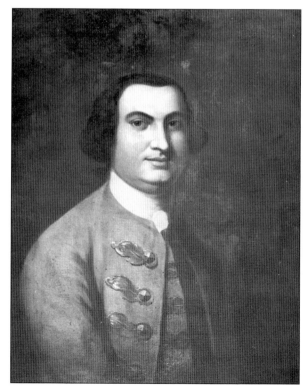

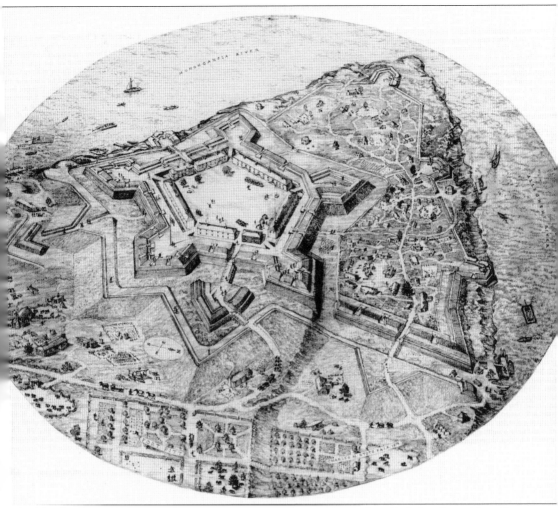

In March, Gen. John Stanwix began construction of Fort Pitt, a five-sided dirt fort with walls 15 feet high and 7.5 feet thick. There were bastions on each corner of the fort. Three were made of earth, and two, the Music Bastion and the Flag Bastion, facing east, were made of brick. The parade ground was bordered by rows of barracks housing nearly 1,000 men. The fort was located along the Monongahela River with a wharf and loading dock. The earthen walls, vulnerable to rain and flood, were covered with blocks of sod held in place by wooden pickets. The earthworks were damaged by the heavy floods in 1762 and 1763 and were vulnerable to grazing cattle and horses. On February 15, 1764, to protect the walls, Bouquet ordered "all dogs & fowl seen upon the Rampart to be killed." Outside the fort along the Allegheny River was a collection of cabins, shacks, and buildings known as Low Town. (Historical Society of Western Pennsylvania.)

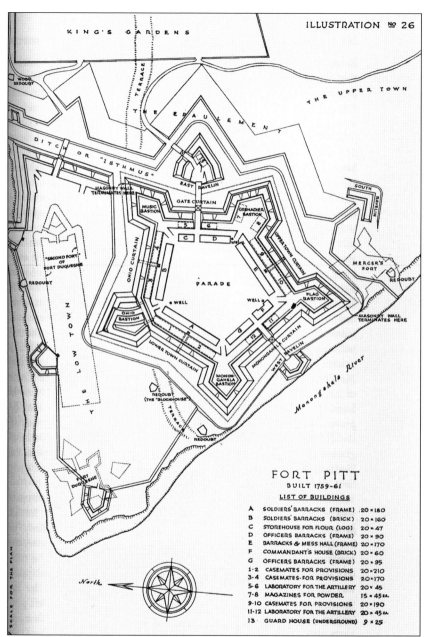

KING'S GARDENS

THE UPPER TOWN

WOOD REDOUBT

TERRACE

THE EPAULEMENT

DITCH OR "ISTHMUS"

MASONRY WALL TERMINATES HERE

EAST RAVELIN

GATE CURTAIN

MUSIC BASTION

GRENADIER BASTION

SOUTH RAVELIN

OHIO CURTAIN

UPPER TOWN CURTAIN

"SECOND FORT" OF FORT DUQUESNE

MERCER'S FORT

REDOUBT

REDOUBT

PARADE

WELL

WELL

WELL

THE LOW TOWN

OHIO BASTION

FLAG BASTION

MASONRY WALL TERMINATES HERE

LOWER TOWN CURTAIN

MONONGAHELA CURTAIN

WEST RAVELIN

REDOUBT (THE "BLOCKHOUSE")

MONONGAHELA BASTION

Monongahela River

TERRACE

REDOUBT

FORT DUQUESNE

FORT PITT
BUILT 1759-61
LIST OF BUILDINGS

A	SOLDIERS' BARRACKS (FRAME)	20 × 180
B	SOLDIERS' BARRACKS (BRICK)	20 × 160
C	STOREHOUSE FOR FLOUR (LOG)	20 × 47
D	OFFICERS BARRACKS (FRAME)	20 × 90
E	BARRACKS & MESS HALL (FRAME)	20 × 170
F	COMMANDANT'S HOUSE (BRICK)	20 × 60
G	OFFICERS BARRACKS (FRAME)	20 × 95
1-2	CASEMATES FOR PROVISIONS	20 × 210
3-4	CASEMATES FOR PROVISIONS	20 × 170
5-6	LABORATORY FOR THE ARTILLERY	20 × 45
7-8	MAGAZINES FOR POWDER	15 × 45 ea.
9-10	CASEMATES FOR PROVISIONS	20 × 190
11-12	LABORATORY FOR THE ARTILLERY	20 × 45 ea.
13	GUARD HOUSE (UNDERGROUND)	9 × 25

North

SCALE FOR THE PLAN

This drawing shows the plan of Fort Pitt and the location of Fort Duquesne (closest to the point) and Fort Mercer (along the Monongahela River). On October 10, 1772, Fort Pitt was sold by the British to William Thompson and Alexander Ross for £50 in New York currency. This ended British control over Fort Pitt. Thompson and Ross leased the compound to Maj. Edward Ward, the same man who had built Trent's Fort two decades earlier. In January 1774, Gov. John Murray of Virginia decided to reassert Virginia's claim to the Forks and sent Dr. John Connolly to drive out Ward and assume control of the region. On April 9, 1773, Connolly took possession of Fort Pitt and renamed it Fort Dunmore. On June 1, 1777, Gen. Edward Hand of the Continental army arrived to take command of the fort during the Revolutionary War. (Historical Society of Western Pennsylvania.)

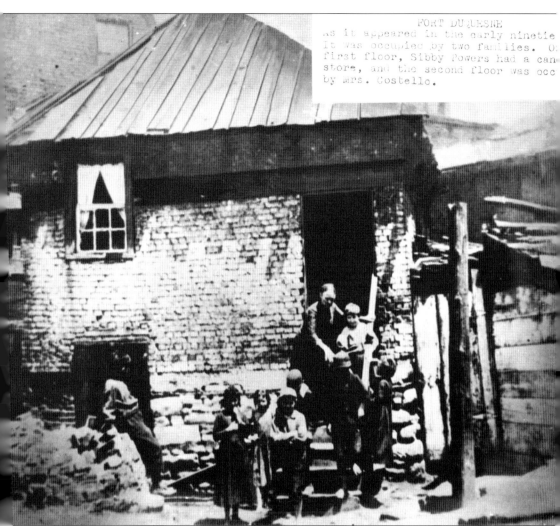

In 1764, Col. Henry Bouquet built a blockhouse to guard Fort Pitt. He wrote Gen. Thomas Gage, "Three sides of this Fort which are not reveted having been rendered almost defenseless by two successive floods in 1762, and 1763, I have caused Three Redoubts to be built on the glacis, to cover them. Two are completed, and the third going on, as fast as weather will permit." One of the redoubts is the blockhouse, the oldest building in Pittsburgh. In 1772, Indian agent Alexander McKee used the blockhouse for meetings with Native American dignitaries. By 1789, George Washington had become president. To counter Native American attacks, he placed Col. Josiah Harmer and Col. Arthur St. Clair at Fort Pitt. Fort Pitt continued as a supply depot until 1792, when its condition had so badly deteriorated that the U.S. Army abandoned the fort and built Fort Fayette at Ninth Street and Penn Avenue. By 1890 the blockhouse had deteriorated to a variety of uses and living quarters, as seen here. (Carnegie Library of Pittsburgh.)

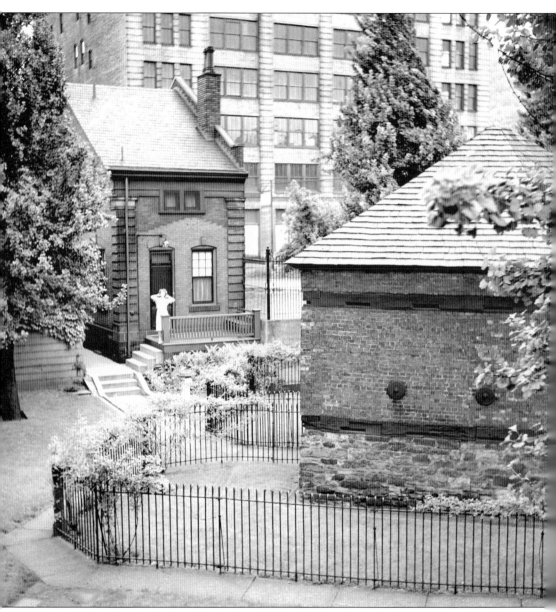

Eventually the Commonwealth of Pennsylvania ceded ownership of the fort to the original Penn family. The Penns sold the fort to former Continental army officers Isaac Craig and Stephen Bayard. It became the home of William Turnbull, and later, Maj. Isaac Craig and his family. In 1837, Col. James O'Hara purchased the property to build a brewery and later rented it to tenants. In 1856, Englishman William Ferguson described the building as "a small brick house with arched windows and doorways, now inhabited by the lowest class." By the end of the 1800s, the fort had been gradually torn down. All that remained was the blockhouse, which was saved from destruction by Mary Elizabeth Schenley, who inherited the property from O'Hara, her grandfather. She donated the property to the Daughters of the American Revolution in 1894, and they restored the building to its original appearance. In this 1950 image the blockhouse was surrounded by houses, freight yards, and warehouses (background). (Carnegie Library of Pittsburgh.)

Two

THE GATEWAY
TO THE WEST

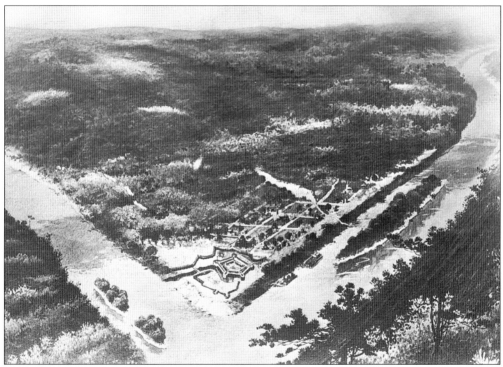

Because Pittsburgh was the last frontier outpost west of the Allegheny Mountains, "the Point" quickly became the Gateway to the West and the center of shipping down the Ohio River to New Orleans and the Gulf of New Mexico. This 1760 illustration of the Point reveals the remoteness of the pioneer wilderness. An early writer observed, "The site is a real amphitheatre, formed by the hand of nature. The rivers flow in channels from 450 to 465 feet below the highest peaks of the neighboring hills. These hills surrounding the city are filled with bituminous coal, which is easily quarried and brought to the city, and affords unequalled facilities for manufacturing operations, (and) for fuel. These hills, though steep, are not generally precipitous, and afford from their verdant slopes and peaks a series of rich and varied landscapes. There is nothing of barrenness visible, but the forests, fields, meadows, orchards and gardens, exhibit one panorama of beauty and abundance." (Carnegie Library of Pittsburgh.)

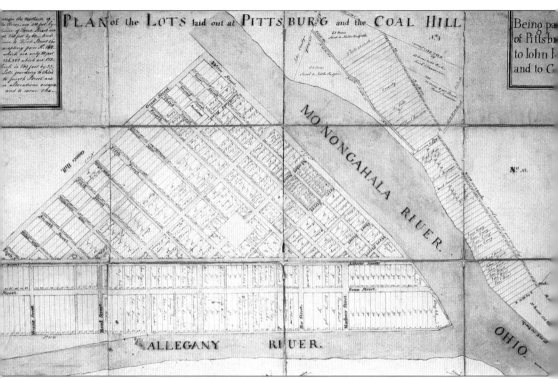

Had the French defeated the British at the Forks of the Ohio River Valley, the people of Pittsburgh would speak French and the city could have been named New Paris or the City of Louis XV. It would have been designed in the French style of a city with grand strolling walkways and great monuments. When the British prevailed, the town was laid out in the English manner of an industrial city with manufacturing and business at its core. The city was planned by John Campbell in 1764 in a four-block area along the banks of the Monongahela River. The streets ran parallel to the river, with the others running back from the river at right angles. The same arrangement was followed along the Allegheny River so that the cross streets from the two rivers met obliquely. In 1799, Col. George Woods redesigned the plan giving Campbell's arrangement greater structure and detail. This survey of Pittsburgh was made by John Hill in 1787. (Carnegie Library of Pittsburgh.)

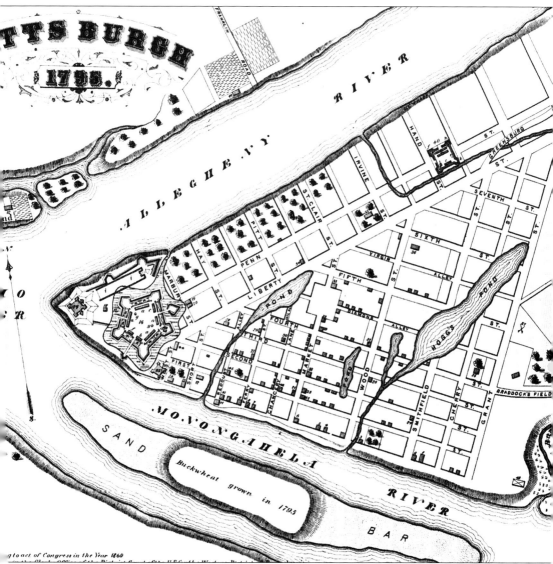

This 1795 drawing shows the position of Fort Pitt and Fort Duquesne. The orchards and fields that fed the town were located along the Allegheny River. Braddock's Road enters the city on the lower right from what is now the Duquesne Bluffs. Hogg's Pond (center) was known as Massacre Pond, referring to Maj. James Grant's bloody defeat by the French in the summer of 1758. Eventually the pond was filled in and 100 years later became the site of Kaufmann's Department store on Smithfield Street. The island in the Monongahela River was accessible by walking across the river in the summer when the water was low. When Col. George Woods named the streets in 1799, he named Grant Street after Maj. James Grant and Smithfield Street after Devereux Smith, an Englishmen who became an American soldier. He sanctimoniously named Wood Street after himself. (Carnegie Library of Pittsburgh.)

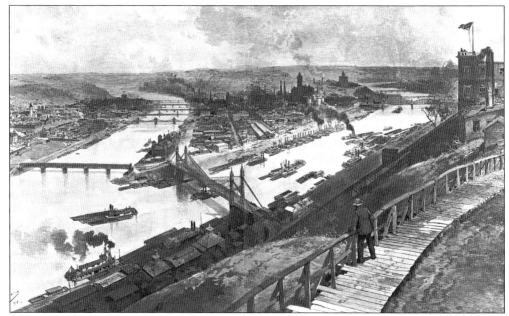

This 1890 engraving looks down on the Point from a wooden walkway along Mount Washington. The Point was primarily a freight station and train yard for the Pennsylvania Railroad. Spanning the Allegheny River at the Point was the covered Union Bridge (left), which was replaced in 1915 by the Manchester Bridge, and crossing the Monongahela River was the Point Bridge (right), built in 1876 and removed in 1927. (Carnegie Library of Pittsburgh.)

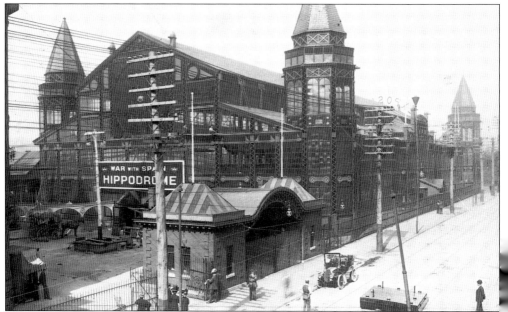

This is a view of Exposition Hall along the Allegheny River at the Point in 1898. A group of civic leaders were determined to advance industry in Pittsburgh. They formed the Pittsburgh Exposition Society and raised $450,000 to build three giant structures—Exposition Hall, Mechanical Hall, and Music Hall—for the purpose of promoting the industries of Pittsburgh. (Carnegie Library of Pittsburgh.)

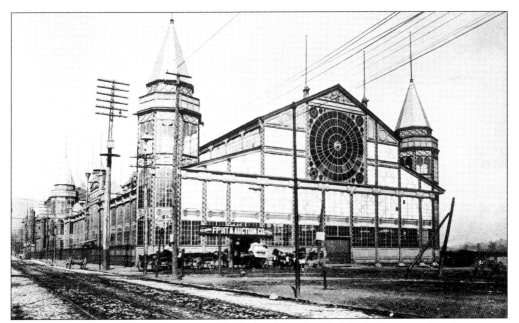

The exposition society buildings were the hub of Pittsburgh life. There were band concerts, lectures, a Ferris wheel, a roller coaster, a merry-go-round, and a boardwalk along the Allegheny River. The second floor of the exposition building had dioramas of the Battle of the Monitor and Merrimac, the Johnstown flood, the San Francisco earthquake, and the sinking of the RMS *Titanic*. It cost 25¢ to see all the exhibits. (Carnegie Library of Pittsburgh.)

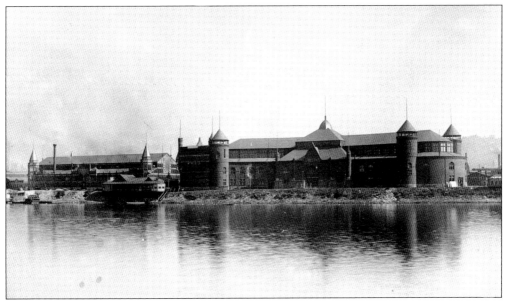

The exposition buildings looked like castles when seen from the Allegheny River in 1900. The annual exhibits focused on Pittsburgh manufacturing and business. The era of the great expositions lasted from 1875 to 1916, when the final exhibition was held. The buildings were used for various purposes until they were torn down in 1950 to make space for Duquesne Boulevard. (Archives Service Center of the University of Pittsburgh.)

This view from Mount Washington in 1950 shows the Manchester Bridge (left) and the Point Bridge (right). Along the Allegheny are the exposition halls, and in the center are the Pennsylvania Railroad yards. The Point is where the Lewis and Clark Expedition began the Voyage of Discovery to the Pacific Ocean in 1804 to explore the Louisiana Purchase for Pres. Thomas Jefferson. (Historical Society of Western Pennsylvania.)

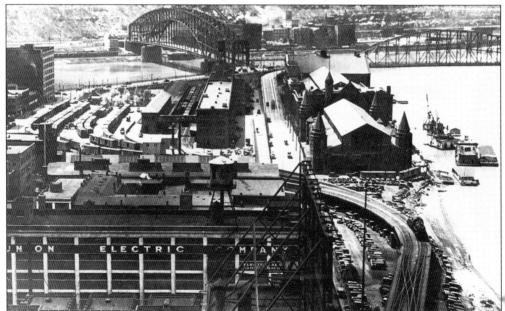

Looking toward the Point in 1945, this image shows the Exposition Hall (right) with docks on the Allegheny River. A tangled assortment of Pennsylvania Railroad yard trestles, freight trains, warehouses, and manufacturing buildings clog the area. When the exposition center ceased to function in 1916, the main building became the Winter Garden Skating Palace, later a warehouse and finally a city automobile compound. (Carnegie Library of Pittsburgh.)

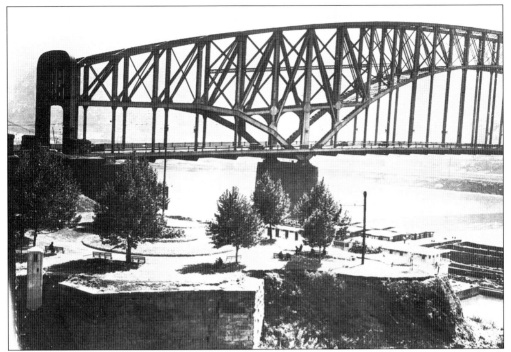

In this 1939 image, the banks of the Point were 25 feet above the rivers and 710 feet above sea level. The Point Bridge is in the background. Today the shoreline of the Monongahela and Allegheny Rivers are 43 feet farther downstream than they were in 1758. (Carnegie Library of Pittsburgh.)

In this image looking toward the point in 1945, the freight houses and yards of the Pennsylvania Railroad station surround the blockhouse (center), making it nearly unnoticeable. The property was regarded as a slum district until 1934 when Mayor David L. Lawrence authorized the Allegheny Conference to revitalize the area. (Historical Society of Western Pennsylvania.)

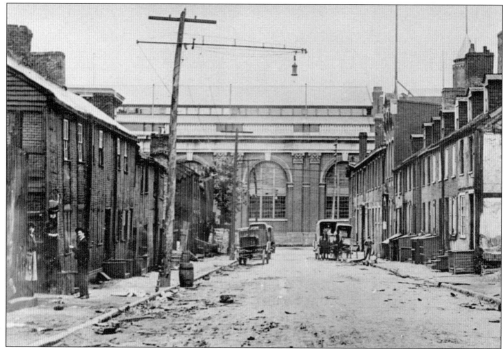

By 1906, the area around Exposition Hall had deteriorated to the point where it was known as skid row. This is a view down First Street, with the main Exposition Hall in the center. A note says the man in the image is "Michael S. Joyce, born at #8 First Street." (Carnegie Library of Pittsburgh.)

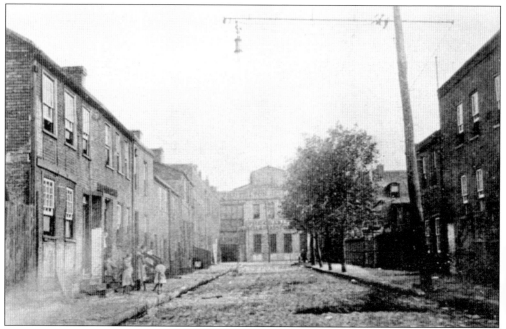

This view of the skid row slums on Fort Street leading toward Exposition Hall shows children playing on the sidewalk. The Point area was a dirty, polluted, unhealthy place where families lived in deplorable conditions. (Carnegie Library of Pittsburgh.)

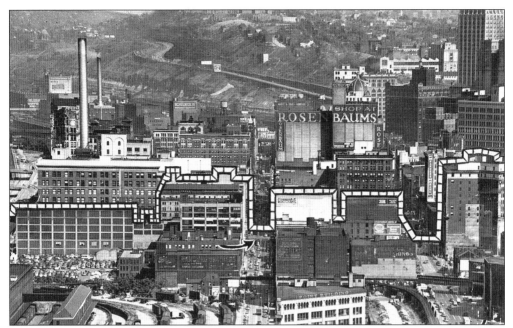

This is a view from the Point looking toward downtown in 1949. The area below the dotted line is the buildings that will be demolished to make way for the new Point Park. The $50 million Gateway Development Project included a 50-acre park and 16 buildings. (Carnegie Library of Pittsburgh.)

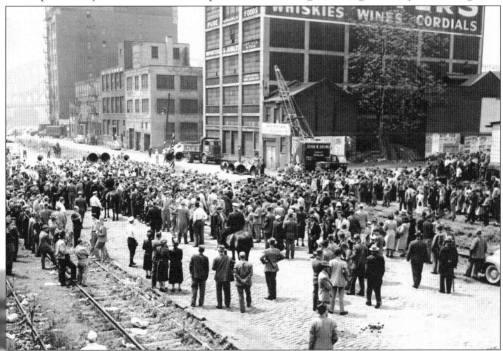

On May 18, 1950, a demolition ceremony was held at the future sight of Point State Park to kick off the beginning of the renaissance program to revive the city. The Allegheny Conference on Community Development had begun pollution control in the 1940s, and by 1950 was ready to revitalize the Point and its redevelopment. (Historical Society of Western Pennsylvania.)

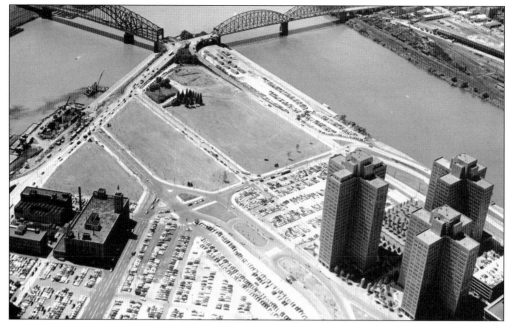

This 1954 view shows the cleared land at the Point. The Gateway Center buildings are in the lower right. The Fort Pitt and Fort Duquesne Bridges have not been built yet. In the center left, construction has begun on the piers of the new Fort Pitt Bridge. The blockhouse can be seen near the center of the image. (Historical Society of Western Pennsylvania.)

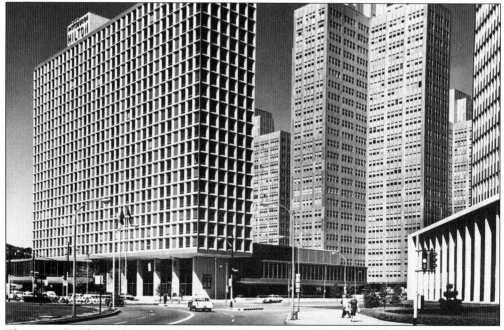

The major buildings of Gateway Center are the Gateway Hilton Hotel (left) and the Gateway Towers Apartments and office buildings (center). On the far right is the state office building. At the time of its opening in 1959, the $15 million Gateway Hilton had one of the world's largest ballrooms, holding 2,000 people. (Carnegie Library of Pittsburgh.)

30

By 1970, Col. Henry Bouquet's blockhouse redoubt had become the centerpiece of the historical redevelopment of Point State Park. Here the blockhouse, restored to its original condition, stands in front of the newly constructed Westinghouse building. All additions have been removed, and the tablet with Bouquet's name that had been placed in city hall was returned. The blockhouse is the oldest remaining structure of frontier Pittsburgh. (Archives Service Center of the University of Pittsburgh.)

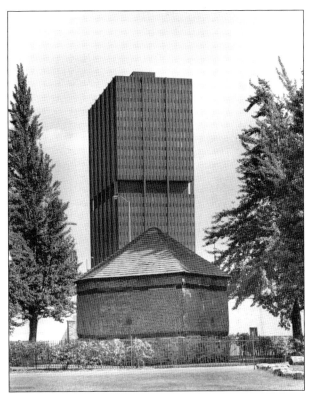

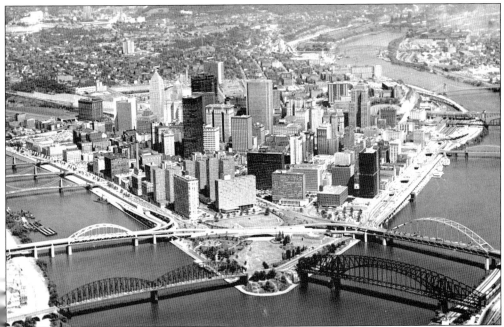

By 1969, only two old bridges remained—the Manchester and Point Bridges—in front of the two new bridges—the Fort Duquesne and Fort Pitt Bridges. The reclamation project was nearly completed. On the plot of land where the decaying railroad property owned by Jay Gould once stood, a great city was going through rebirth. (Historical Society of Western Pennsylvania.)

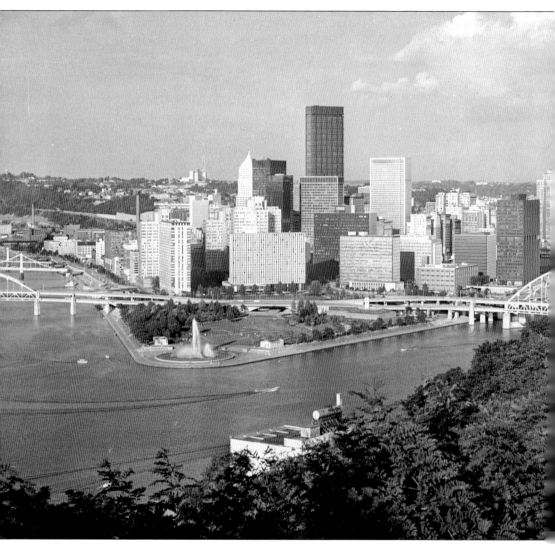

This 1974 image shows the completed Point and fountain that sprays water 150 feet into the air. The first Pittsburgh Renaissance had controlled floods, eliminated pollution, and turned an unsightly Point district into a garden park. Under the combined leadership of Richard King Mellon and Gov. David Lawrence the Point had become the crown jewel of their commitment to revitalize the city. Joining them were a group of business, community, and civic leaders. Hugh Breckenridge wrote in 1806, the "finest gardens in the world may be formed at the Point." Following 150 years of neglect, the Point, known as the Gateway to the West, was beginning to flourish, and the garden was beginning to grow. New roadways, buildings, public spaces, and clean air dramatically changed the Point from a skid row slum into a stunning centerpiece for the city. (Carnegie Library of Pittsburgh.)

Three

A City Emerges from a Frontier Town

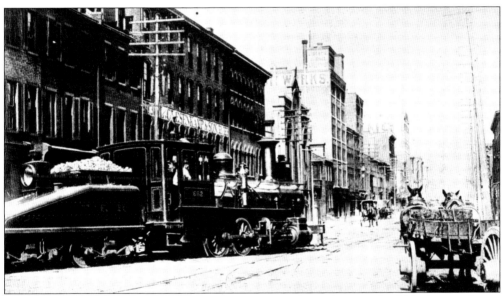

Pittsburgh grew rapidly from a frontier town into an industrial center. In 1761, the population of Pittsburgh was 163 men, 45 women, and 25 children living in 160 houses. In 1764, John Campbell made the first plans for the town. In 1766, the first shingled building was erected. In 1787, the first Market House was opened on Second Avenue. In the same year John Penn and John Penn Jr. donated two and a half acres of land for the building of Trinity Church. In 1786, Pittsburgh's first newspaper, the *Gazette*, was printed on a handpress in a log house on Water Street. In 1788, the first mail service from Philadelphia arrived at the *Gazette* office, announced by loud blasts of a horn. Incoming letters were paid for by the recipient. In 1793, the first courthouse and jail were built. The city grew so rapidly that by 1900, the Pennsylvania Railroad Company had steam engines running down the middle of Liberty Avenue (above) to its freight warehouses at the Point. (Carnegie Library of Pittsburgh.)

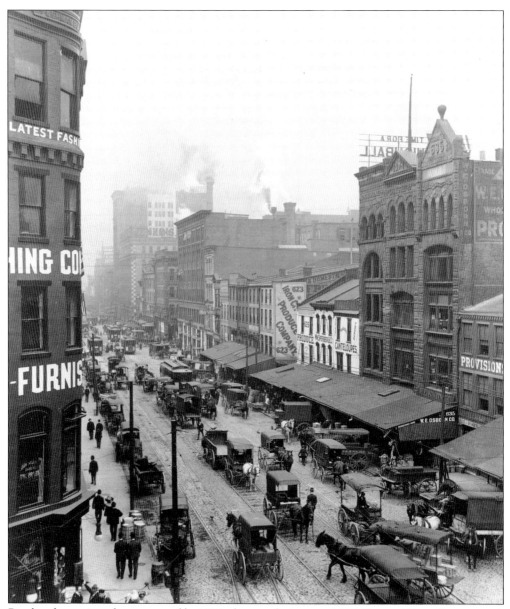

Pittsburgh continued to grow, and by 1802, the population was 1,565. Four public wells were sunk to replace river water. The Pittsburgh Bank opened in 1804 on Second Avenue, complicated by the different British, French, and American currency in circulation. The first stagecoach line opened between Pittsburgh and Philadelphia taking one week to make the $20 journey. In 1815, only Wood and Market Streets were paved and citizens heaved their garbage into the streets. In 1816, Pittsburgh was incorporated as a city and Ebenezer Denny was elected as the first mayor. Whale oil lamps were installed in the streets, and boys used them as target practice for their slingshots. In 1852, the Pennsylvania Railroad route from Philadelphia to Pittsburgh was completed. In 1879, the first electric lights were installed on public streets. By the time of this image in 1906, the 600 block of Liberty Avenue (above) emerged as the primary market district of the city. In 1820, the population was 7,248; by 1850, 46,601; by 1870, 86,076; and by 1890, 238,617. (Historical Society of Western Pennsylvania.)

As Pittsburgh emerged from a frontier town, it was the small-business person who provided the infrastructure of the city. Here Henry Ahlers stands at the entrance to H. & C. F. Ashlars Custom Tailors at 420 Smithfield Street in 1880. Pins were a luxury costing seven pence apiece in Philadelphia. Clothiers advertised doeskins, velvet, linens, fur, wool, felt hats, and silk stockings. (Carnegie Library of Pittsburgh.)

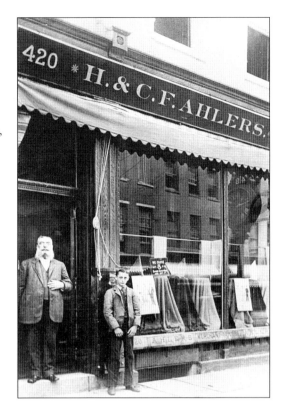

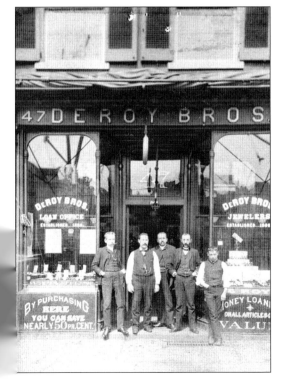

The DeRoy Brothers Jewelers had been in business for over 35 years when this image was taken in early 1880. Located at 47 Smithfield Street, it became 407 Smithfield Street when a change in the numbering system took place in 1884. One of the first jewelers was John M. Roberts, who opened his shop in a log cabin at Fifth Avenue and Market Street in 1832. (Carnegie Library of Pittsburgh.)

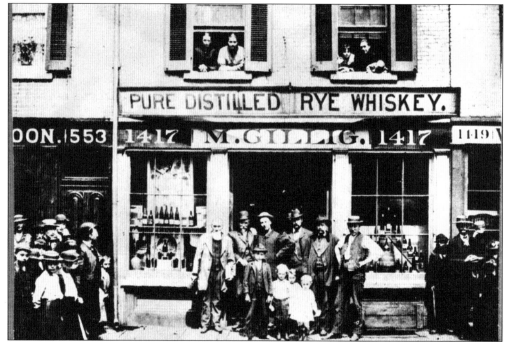

For a period of time, more whiskey was made in Pittsburgh than anywhere else in the country and distilling was the most profitable business in town. One-fifth of all farmers were distillers. Increased government taxes led to the Whiskey Rebellion in November 1795. Pres. George Washington sent 10,000 troops to Pittsburgh to put down the rebellion. This image shows the employees of M. Gillig at 1417 Penn Avenue in 1883. (Carnegie Library of Pittsburgh.)

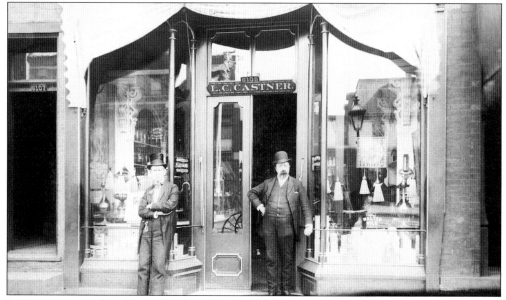

L. C. Castner stands in front of his drugstore at 6109 Penn Avenue. Dr. A. J. Davis, an East Liberty physician, wears a stovepipe hat. Sickness was a mystery in early Pittsburgh. Cholera epidemics killed hundreds each year. Citizens built coal fires under pitch pots in the streets because they thought the smoke would drive away the disease. (Carnegie Library of Pittsburgh.)

Gernert, Guenther and Eyth sold Stect pianos at 440 Wood Street in 1888. In front of the store is a piano in a crate ready to be delivered. J. B. Kaercher Hardware was located next door at 442 Wood Street. (Carnegie Library of Pittsburgh.)

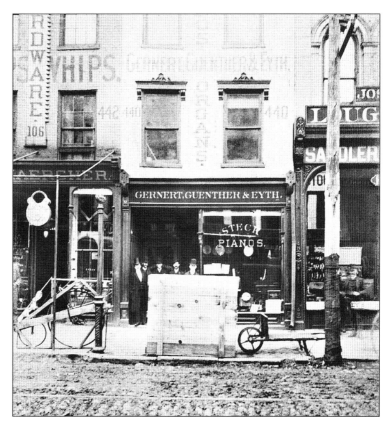

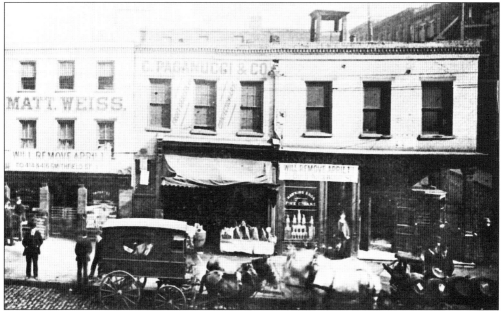

The Matt Weiss Company was located on the southeast corner of Smithfield Street and Diamond Street before its demolition in 1890. The sign says it will remove (relocate) on April 1 to 414–416 Smithfield Street. (Carnegie Library of Pittsburgh.)

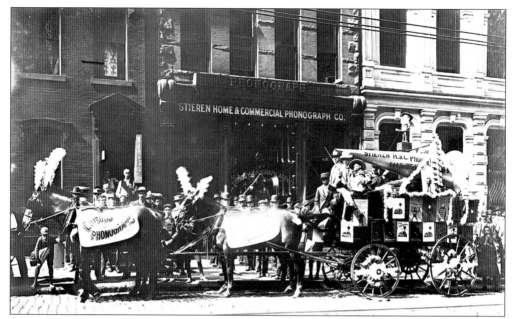

The Stieren Home and Commercial Phonographic Company was located at 544 Smithfield Street in 1900. As early as 1818, *Darby's Emigrant Guide* wrote, "Pittsburgh is by no means pleasant city to a stranger. The constant volume of smoke preserves an atmosphere in a continuous cloud of coal dust." (Carnegie Library of Pittsburgh.)

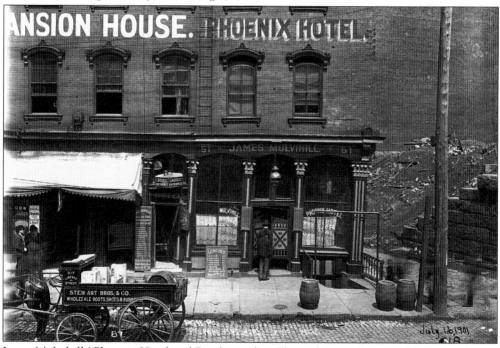

James Mulvihills' Phoenix Hotel and Bar, located on Eleventh Street between Liberty and Penn Avenues, was open for business on July 16, 1901. A wagon is parked outside. A man, perhaps the driver, is entering the saloon through the swinging doors, with the ladies entrance to the left. (Carnegie Library of Pittsburgh.)

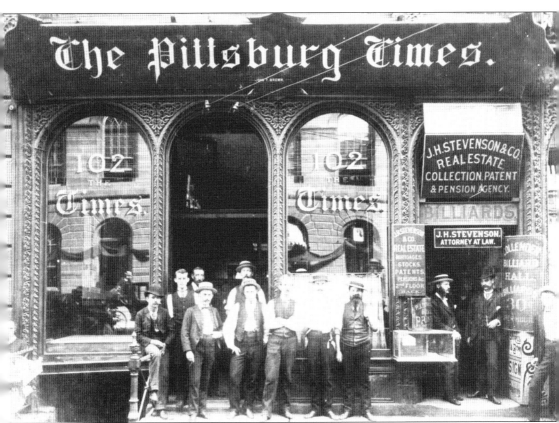

The *Pittsburg Times* office was located at 102 Fifth Avenue. In this July 1885 image, the reflection in the window is the post office, draped in mourning because of the death of Ulysses S. Grant. Pittsburgh is spelled without the *h*. Pittsburgh has been officially spelled with an *h* since its founding in 1758. *Burgh* is a variant of the Scottish *borough*. Gen. John Forbes, who named the city, was a Scot and would have pronounced it "Pitts-burro," as Edinburgh, Scotland, is pronounced "Edin-burro." In 1890, the United States Board on Geographical Names decided that the final *h* was to be dropped from the names of all cities and towns ending in *burgh*. In 1911, after protest from citizens, the board reversed its decision and restored the *h* to Pittsburgh, which is now the only "burg" in America that ends in an *h*. (Carnegie Library of Pittsburgh.)

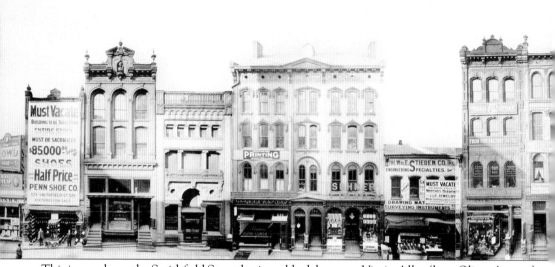

This image shows the Smithfield Street business block between Virgin Alley (later Oliver Avenue) and Sixth Avenue in 1908. Within a year, most of the street was cleared for erection of the 25-story Oliver Building. The third building from the right is the location of the engineering firm of William E. Stieren. It was originally the location of Mellon Bank, built in 1873 by T. Mellon and Sons as a four-story "iron front" building at 512 Smithfield Street in the center of the block. By 1900, the population of Pittsburgh was 321,616 people. (Carnegie Library of Pittsburgh.)

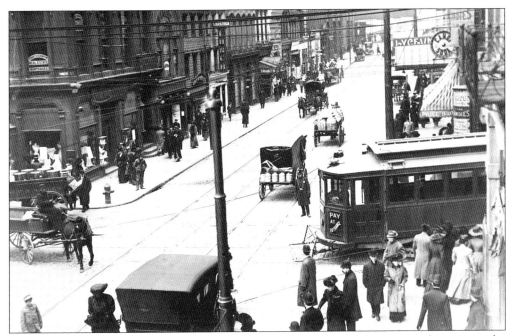

Freight wagons, streetcars, pedestrians, and an occasional automobile compete for space at the corner of Sixth Street and Penn Avenue in 1906. A uniformed police officer can be seen in the middle of Penn Avenue directing traffic. (Carnegie Library of Pittsburgh.)

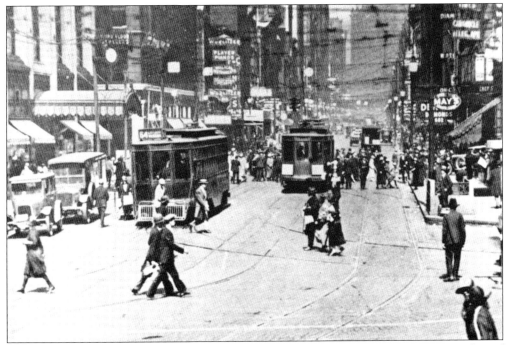

Liberty Avenue looking toward the Point in the early 1900s shows the growing vitality of downtown. (Carnegie Library of Pittsburgh.)

To grow, Pittsburgh had to solve a big problem. There was an enormous hill surrounding Grant Street that caused a difficult climb for pedestrians, horses, and wagons. It was named after Maj. James Grant who lost 800 soldiers in an attack on Fort Duquesne on September 7, 1758. The hill strangled any expansion of the city. There were two unsuccessful attempts to remove the hump in 1836 and 1849. This is a view of Grant Street between Oliver and Sixth Avenues on September 12, 1912, after the third and final attempt. The dotted line shows the original grade of the hump. The courthouse is on the right. The planning for the project began in 1909. The deepest cut was 16 feet near the courthouse. The removal of the hump cost $800,000 with another $2.5 million for property damages. (Carnegie Library of Pittsburgh.)

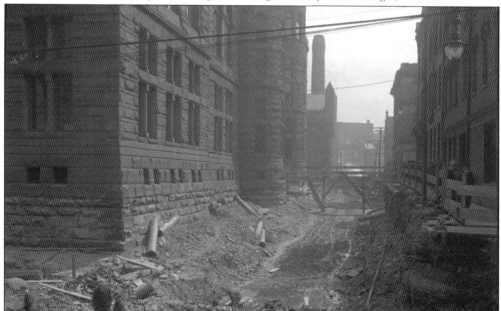

The intersection of Grant Street and Diamond Street looking east shows the progress of the hump cut on March 28, 1913, and is now one story below the original ground level. The present-day street level of the courthouse is actually the original basement. That is why the current street-level windows are so small. (Archives Service Center of the University of Pittsburgh.)

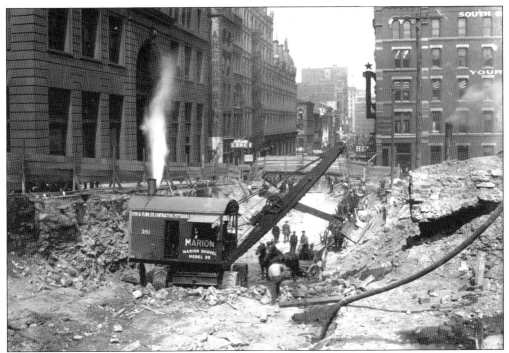

A steam shovel lowers the hump at Fifth Avenue near Grant Street on June 12, 1912. The courthouse is on the left. (Archives Service Center of the University of Pittsburgh.)

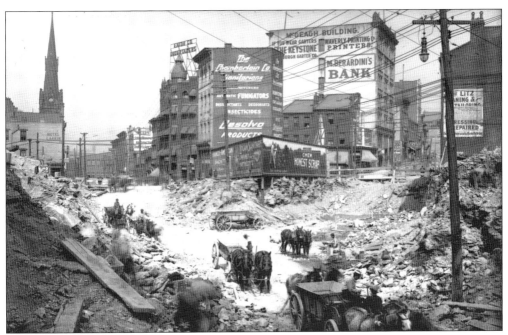

The hump cut progresses on September 12, 1912. Here is the cut on Grant Street between Oliver Avenue and Sixth Avenue, which is now the area between the Omni William Penn Hotel and One Mellon Bank Center, with the steeple of First Lutheran Church in the background. Freight wagons wait to haul away debris. (Archives Service Center of the University of Pittsburgh.)

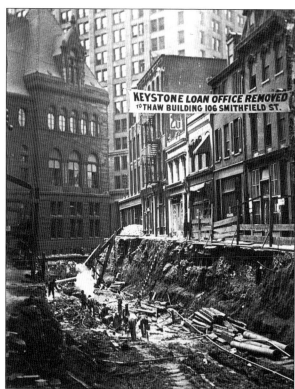

This image shows the hump cut on Grant Street and Fifth Avenue in 1912, with the courthouse in the left background. Workmen are putting sewage pipes in place a full story below the previous ground level. Excavations were as deep as 16 feet, the deepest being the one shown here. (Carnegie Library of Pittsburgh.)

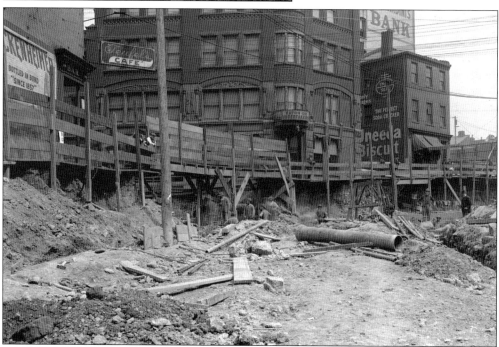

The hump cut progresses at the corner of Grant Street and Sixth Avenue on May 6, 1913. Eaton Company Undertakers can be seen in the center just above the supports and walkway. (Archives Service Center of the University of Pittsburgh.)

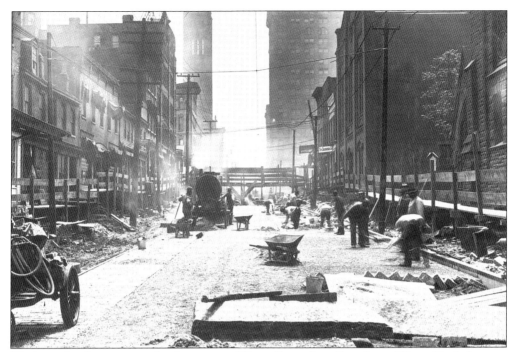

The hump has been removed and repaving of Grant Street from Strawberry Way to Sixth Avenue, the present site of the U.S. Steel Tower, is well underway in 1913. Pedestrian walkways have been constructed to cross Grant Street. The First Lutheran Church is in the right foreground and the courthouse tower in the background. (Carnegie Library of Pittsburgh.)

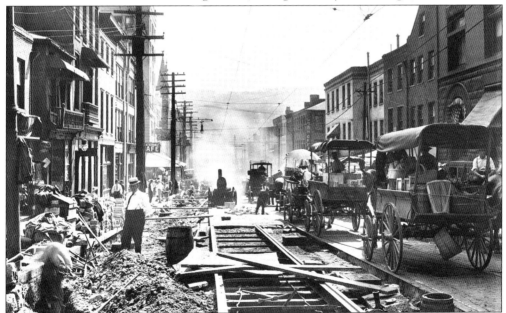

Grant Street is being repaved in cobblestone from Fourth Avenue to Third Avenue on August 11, 1913, after the removal of the hump. The supervisor is in the tie and straw hat. Traffic flows one way on the right. When the hump cut was completed, Pittsburgh was able to expand all the way to the Bluff at the west end of the city. (Carnegie Library of Pittsburgh.)

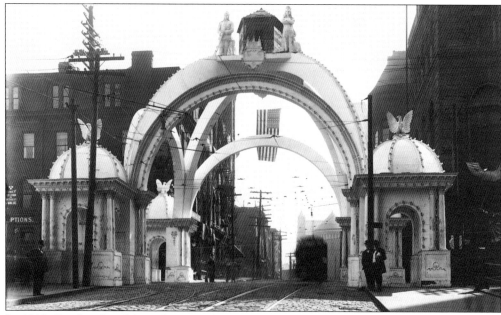

In 1908, Pittsburgh celebrated its 150th birthday, dating from 1758 when Gen. John Forbes named Fort Pitt. This is the Sesquicentennial Arch at the corner of Fifth Avenue and Grant Street. The celebration began on Sunday, September 27, 1908, when all the churches in the city simultaneously rang their bells. Pittsburgh had emerged from a frontier town into one of the most important cities in America. (Carnegie Library of Pittsburgh.)

On October 1, 1908, an estimated 300,000 people closed the sesquicentennial celebration with a parade through downtown ending at Fifth Avenue and Liberty Avenue (seen here). It was the grandest pageant ever held in Pittsburgh. The year 2008 marks the 250th anniversary of the city. (Carnegie Library of Pittsburgh.)

Four

WELL-KNOWN PLACES

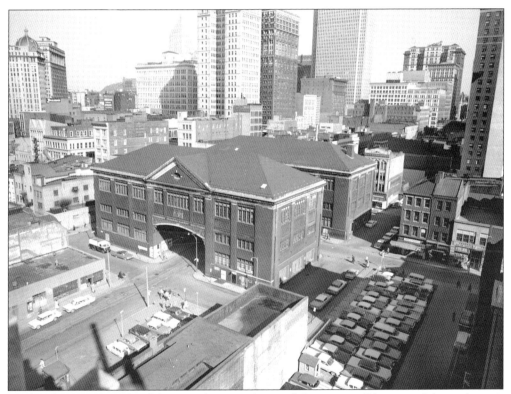

Pittsburgh is a town of well-known places, and one of the most well-known of these places is Market Square. In 1784, descendents of William Penn deeded a strip of land to the city for use as a public square. Farmers, butchers, and bakers were quickly drawn to the site as a market, and by 1787, the first Market House was built. By the 1850s, a complex of two connected buildings opened. In the early 1900s, the buildings were destroyed by fire, and in 1915, a massive H-shaped redbrick structure was built and called the Diamond Market House. Seen here in 1961, the Diamond Market House was known for its connecting archways. Located in what are now Market Square and PPG Place, this area has been a gathering place for over 200 years. (Carnegie Library of Pittsburgh.)

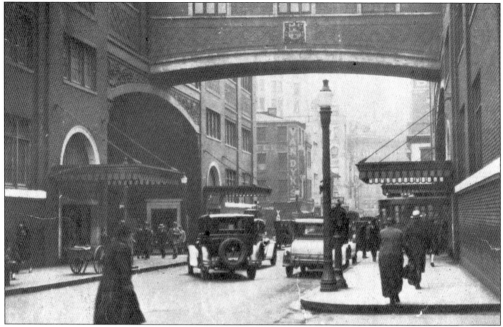

This view of the Diamond Market House in 1929 shows Diamond Street, which ran through the center of the two buildings parallel with the arch walkway (center). The Market Square consisted of four blocks in the heart of town with high Victorian Gothic storefronts along the neighboring streets. (Carnegie Library of Pittsburgh.)

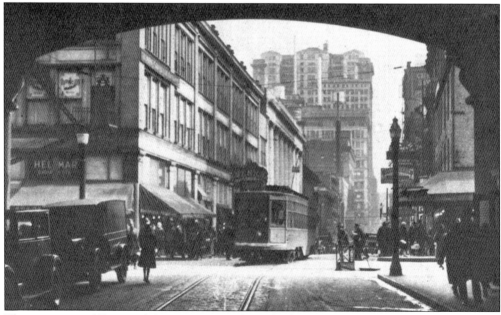

This is a view of Diamond Street as it ran through the Diamond House Arch in 1930. The Market House was connected by Market Street to the Monongahela Wharf where produce and goods were delivered to the city by boat. Pittsburghers called the square the Diamond. The buildings covered 11,000 square feet, including the main arches that spanned Diamond Street, which is now Forbes Avenue. (Carnegie Library of Pittsburgh.)

This view of the Diamond Market area shows the teeming activity of pedestrians, cars, and streetcars surrounding the market along Liberty Avenue and Ferry Street (now Stanwix Street) looking from the Point toward the market in July 1951. When the Diamond Market House opened in 1915, it had an exhibition hall and boxing ring on the second floor. (Carnegie Library of Pittsburgh.)

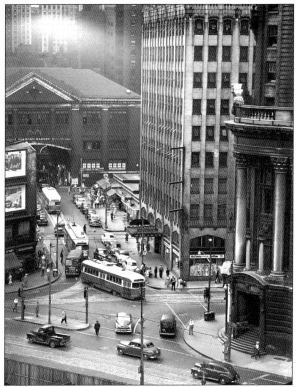

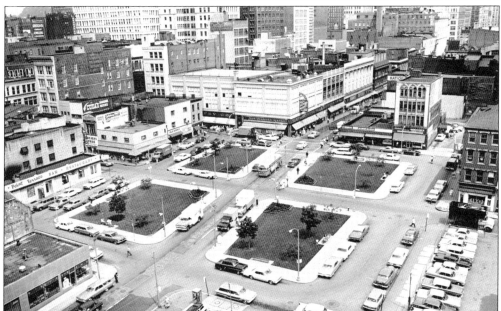

In this image from 1961, the Market House buildings have been torn down and demolished. The architecture of the buildings around the square is varied and undistinguished because they were never meant to be seen. The Diamond Market House completely dominated them. In this image, the new Market Square will soon be developed into Market Square Park. (Historical Society of Western Pennsylvania.)

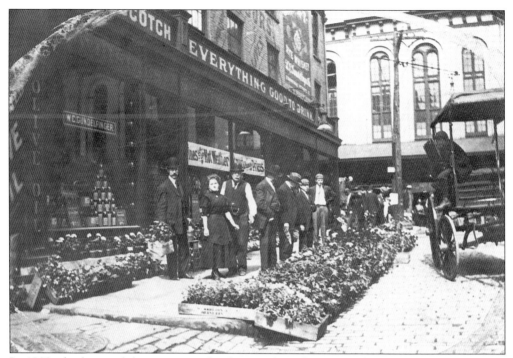

In 1908, the heart of shopping was the Diamond Market House (background) on Diamond Street. Goods and produce were sold on the cobblestone streets in front of the stores. The sign on the building reads, "Scotch, Everything Good to Eat." (Carnegie Library of Pittsburgh.)

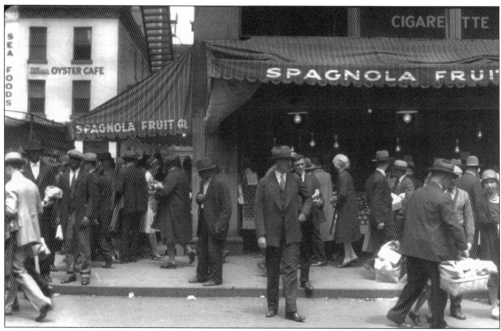

The Spagnola Fruit Company, seen here in 1928, was located on Forbes Avenue in Market Square. In the back left is the Oyster House Café, which opened its doors in 1870. It is the oldest bar and restaurant in town. (Archives Service Center of the University of Pittsburgh.)

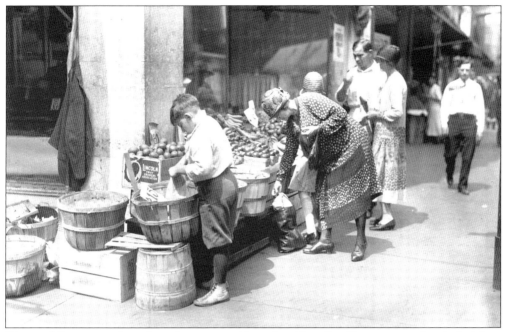

Diamond Square goods and produce were sold on the sidewalks. Here a young boy in knickers is shopping on August 11, 1926. Children loved to go to the market. At one time, there was a roller-skating rink on the third floor of the Diamond Market building. (Archives Service Center of the University of Pittsburgh.)

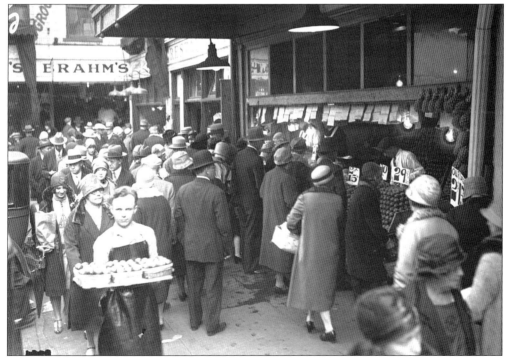

Sidewalks are bustling with activity and shoppers as a young boy peddles his goods on West Diamond Square on May 26, 1928. (Archives Service Center of the University of Pittsburgh.)

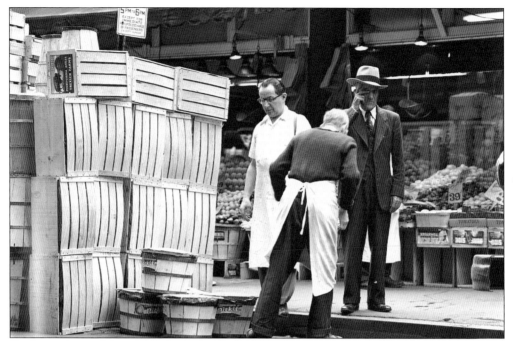

Produce is being delivered on Diamond Street in June 1951. Market Square was not a square; it was a marketplace with no definable boundaries. (Carnegie Library of Pittsburgh.)

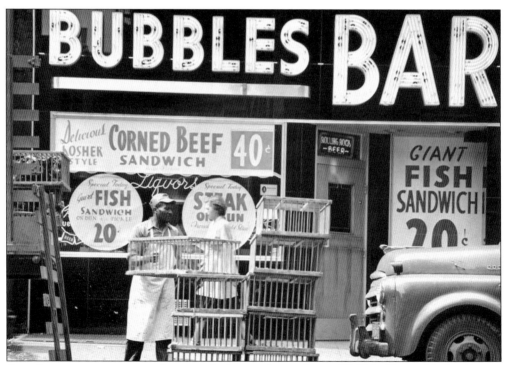

A worker prepares empty wooden cages for live poultry in front of Bubbles Bar on Market Square in 1951. The cage on the left contains live chickens. Bubbles Bar was known for its large corned beef and fish sandwiches. (Carnegie Museum of Art.)

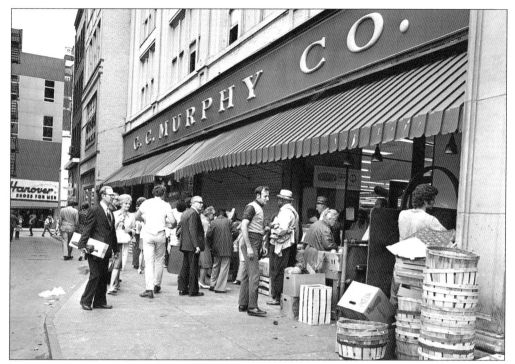

People gather in 1974 around the G. C. Murphy Company fruit and vegetable stand founded by George C. Murphy in 1906. The G. C. Murphy Company featured a well-known restaurant and cafeteria. (Carnegie Library of Pittsburgh.)

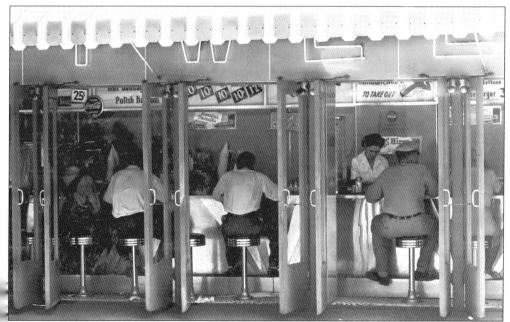

Long, narrow, open-air lunch counters were common around Market Square. This counter was located at the corner of Diamond and Wood Streets and shows customers eating lunch on July 11, 1951. (Carnegie Library of Pittsburgh.)

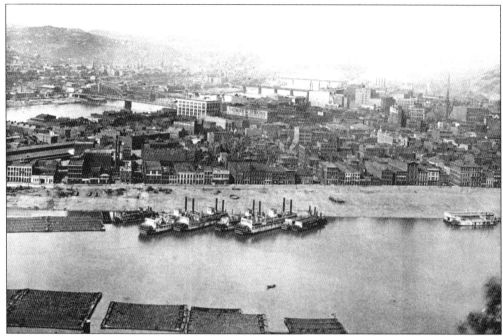

Another well-known place was the Mon Wharf, shown here in 1893. For over a century it was the busiest inland port in America and was the central driving force in the commerce of the city. From the wharf's cobblestone banks, Market Street ran directly to the Diamond Square Market House where goods and freight were immediately sold. The blocks along Water Street, seen here, are the oldest surviving buildings in Pittsburgh. (Carnegie Library of Pittsburgh.)

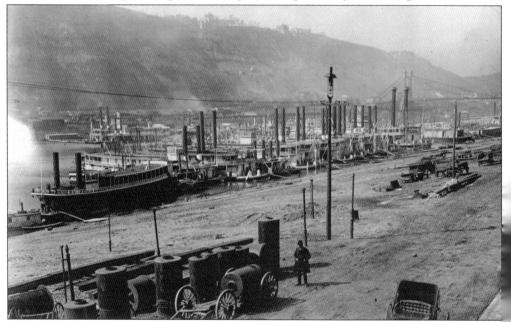

This 1895 image shows the Mon Wharf along Water Street. Before dams and locks were built to solve the low water problem, the wharf was filled with boats waiting for the spring rains to make navigation down the Ohio River possible. (Archives Service Center of the University of Pittsburgh.)

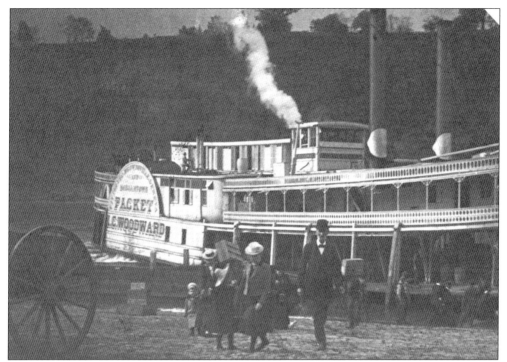

This 1900 image shows the Samuel P. Large family arriving at the Mon Wharf for a much-anticipated day of shopping in downtown Pittsburgh. Large proudly leads his family up the wharf from the steamboat to the heart of the commercial district. (Carnegie Library of Pittsburgh.)

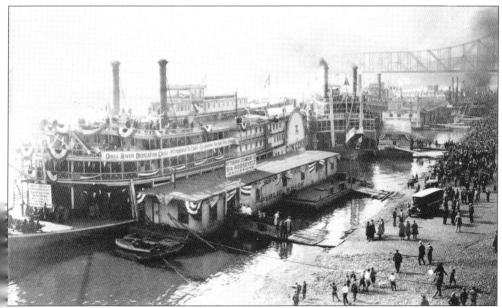

On October 18, 1929, people gathered on the Mon Wharf to celebrate the completion of 50 locks and dams allowing an all-year, nine-foot channel of water from Pittsburgh to Cairo, Mississippi. The sign on the Pittsburgh Steamboat Company steamer *Cincinnati* reads, "Ohio River Dedication Cruise, Pittsburgh to Cairo." (Carnegie Library of Pittsburgh.)

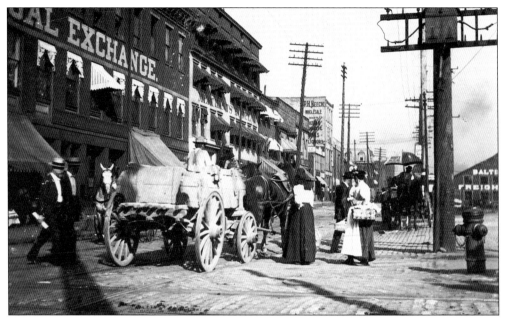

Men and women are shopping in front of the Coal Exchange Building at the corner of Wood and Water Streets on the Mon Wharf in 1900. The street was first laid out by George Woods in 1784. The lots are narrow strips of land located between Water Street (Fort Pitt Boulevard) and First Avenue. The present-day buildings have double facades because they stretch from one street to the other. (Carnegie Library of Pittsburgh.)

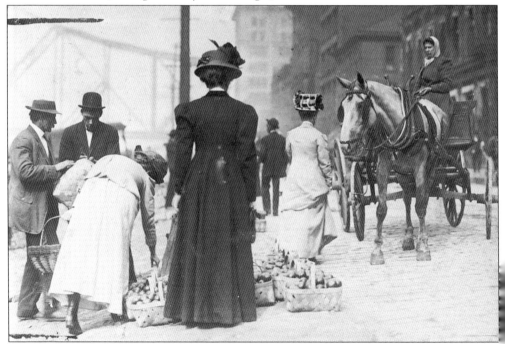

Two Pittsburgh women encounter each other at the Mon Wharf in 1905. One wears a babushka to cover her head and is driving a freight wagon. The other wears a hat and is shopping for fresh apples. (Carnegie Library of Pittsburgh.)

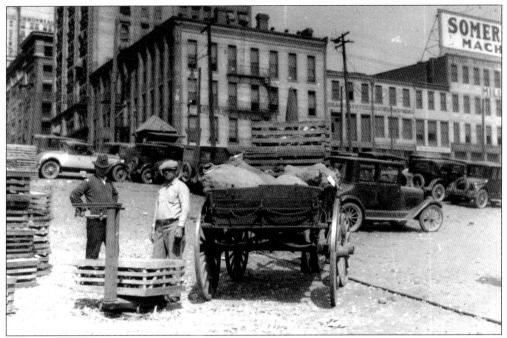

Two men are weighing freight to place in a wagon along Water Street on the Mon Wharf on September 6, 1929. (Archives Service Center of the University of Pittsburgh.)

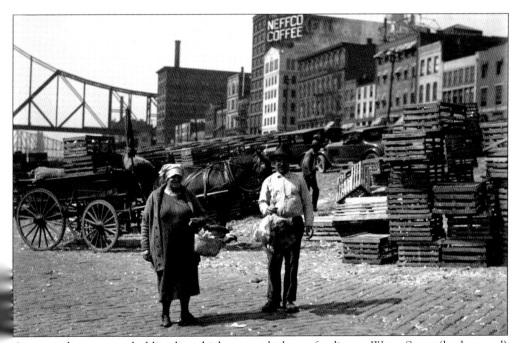

A man and woman are holding live chickens to take home for dinner. Water Street (background) has a variety of architectural styles, including plain vernacular, Italianate, Queen Anne, high Victorian Gothic, and Romanesque. The Wabash Bridge (left, background), a cantilevered bridge, was torn down in 1948. (Archives Service Center of the University of Pittsburgh.)

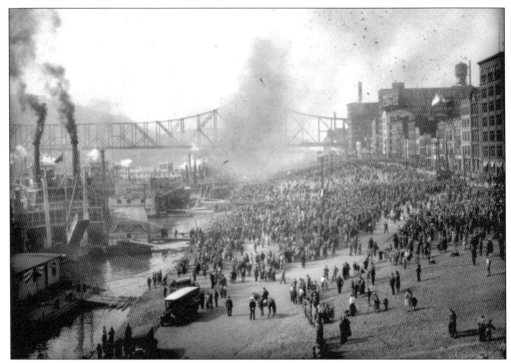

A crowd gathers to celebrate improvements to the Mon Wharf on October 18, 1929. The wharf was cobblestoned and steeply sloped toward the river. (Archives Service Center of the University of Pittsburgh.)

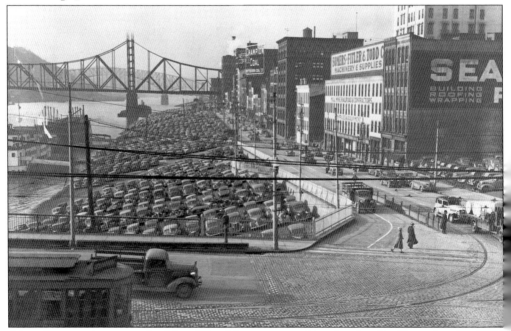

After the steamboat era, the Mon Wharf became a parking lot. In this December 12, 1936, view of Water Street, traffic can be seen making its way over the Smithfield Street Bridge to downtown. The Wabash Bridge is in the background. (Carnegie Library of Pittsburgh.)

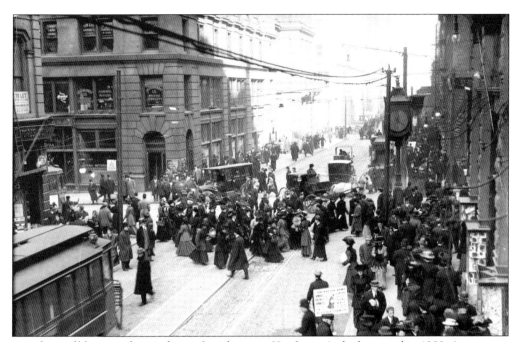

Another well-known place is the six-foot-diameter Kaufmann's clock erected in 1888. A common saying was "meet me under Kaufmann's clock." Here people are crossing the busy intersection at the corner of Smithfield Street and Fifth Avenue under the clock in 1915. There is a Salvation Army sign in the foreground asking for donations. (Carnegie Museum of Art.)

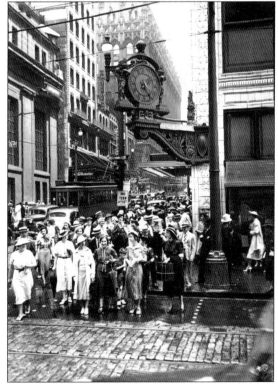

Kaufmann's Department Store, called "the Big Store," was founded in 1871 by brothers Morris, Isaac, Henry, and Jacob Kaufmann. The first store was located on Carson Street in the South Side. As the business grew, the store was moved to Fifth Avenue and Smithfield Street, seen here in 1940. It was one of five major downtown department stores along with Rosenbaum's, Horne's, Gimbel's, and Frank and Seder's. (Historical Society of Western Pennsylvania.)

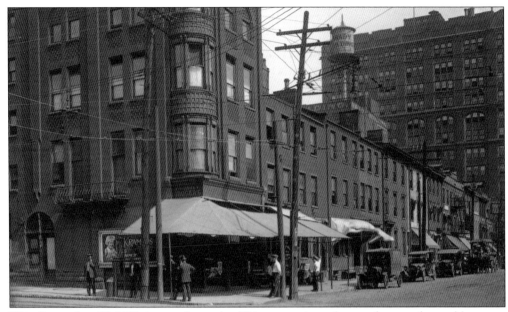

This September 15, 1921, image shows the Chinese section of town that was located between Second Avenue and Grant and Ross Streets. It consisted of a series of Chinese grocery stores. Today this is the intersection of the Boulevard of the Allies and Grant Street. (Archives Service Center of the University of Pittsburgh.)

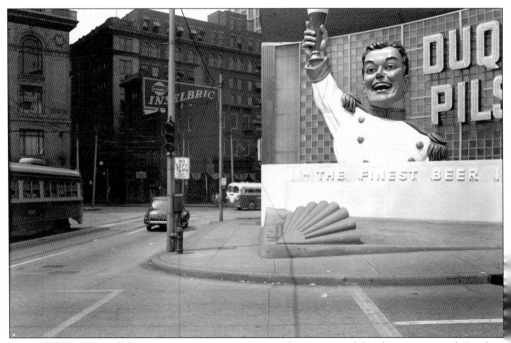

One of the most well-known signs in town was at the corner of Sixth Avenue and Bigelow Boulevard. Here on August 3, 1947, the famous Duquesne Pilsner Boy is toasting passersby to "Have a Duke." Duquesne beer was known as the "Prince of Pilsners." Today the U. S. Steel Tower occupies this site. (Archives Service Center of the University of Pittsburgh.)

Five

LANDMARK BUILDINGS

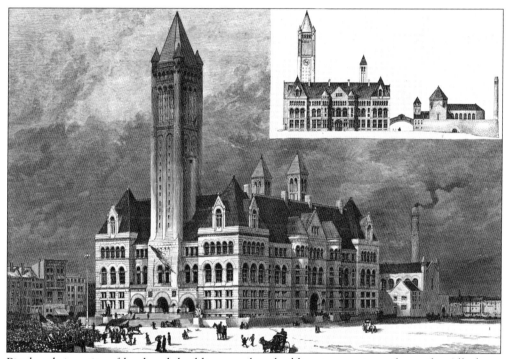

Pittsburgh is a city of landmark buildings, and no building is as noteworthy as the Allegheny County Courthouse. This image appeared in *Harpers Weekly* on February 28, 1885. Some historians consider it to be the most distinguished American building of the 19th century. A tribute to the architect on the third floor reads, "In memory of Henry Hobson Richardson, Architect, 1838–1886. Genius and training made him master of his profession. Although he died in the prime of his life, he left to his country many monuments of art, foremost among them this temple of Justice." The building was dedicated on July 4, 1888. Richardson died two years before its completion. His commission was to design a building that could carry out the normal everyday business of a city while supervising the most violent of criminals. The 325-foot-high tower symbolized the portal of the city, the courtyard was the gathering place, and the penitentiary was the place of justice. (Carnegie Library of Pittsburgh.)

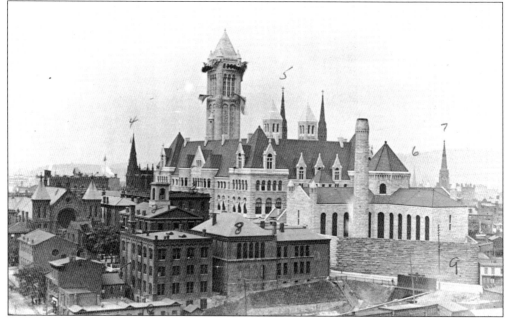

This 1899 image reveals the massive stone structure standing among its lesser surroundings. During construction of the Romanesque masterpiece, architect Henry Hobson Richardson was reported to have said, "If they honor me for the pygmy things I've done, what will they say when they see the Pittsburgh Courthouse?" (Historical Society of Western Pennsylvania.)

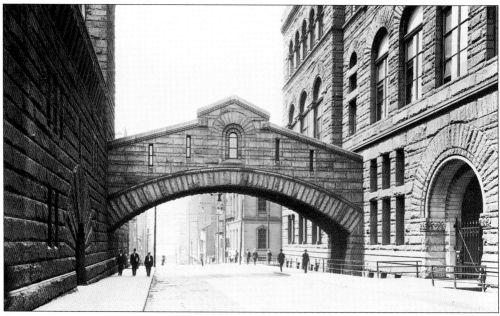

Spanning Ross Street, the Bridge of Sighs connects the courthouse to the jail. It was copied after the 16th-century Bridge of Sighs in Venice, Italy, where prisoners would sigh at their final view of Venice before being taken down to their cells. Because the jail could not comply with a federal court order addressing crowding limitations, a new jail was built in 1995 along the Monongahela River. (Carnegie Library of Pittsburgh.)

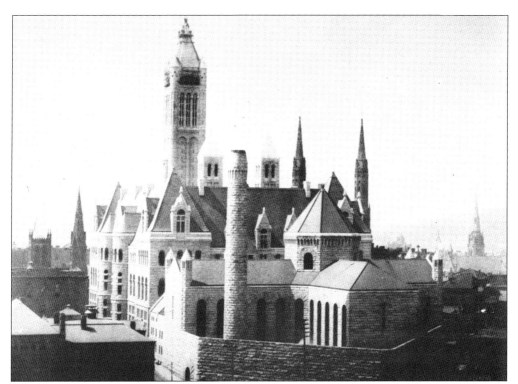

This view shows the penitentiary that was designed in the Auburn style of correctional philosophy with austere surroundings to give opportunity for "reflection on past deeds in silence." The cells face stone walls rather than looking toward each other, which creates an atmosphere of stern isolation. (Carnegie Library of Pittsburgh.)

This landmark building was the Bank of Pittsburgh on Fourth Avenue, designed by John Chislett in the Greco Ionic style in 1835. Fourth Avenue was called the "Wall Street" of Pittsburgh because it was the early banking center of the city. The bank was demolished in 1896 for the New Bank of Pittsburgh building. (Carnegie Library of Pittsburgh.)

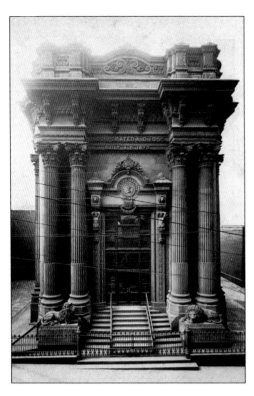

The Dollar Savings Bank on Fourth Avenue and Smithfield Street was built in 1871. It was designed as a Connecticut brownstone baroque-style building. At the base of the Roman Corinthian columns are two sculptured lions guarding the entrance to the bank. They are intended to symbolize the heavy security under which the money was placed. They still stand guard at the bank portals today. (Carnegie Library of Pittsburgh.)

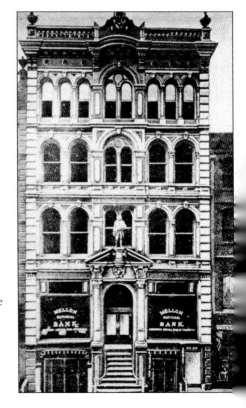

This image shows the T. Mellon and Sons Bank building on Smithfield Street in 1872. When Judge Thomas Mellon resigned as a judge in 1869, he opened Mellon Bank saying "any man who could not get rich in Pittsburgh within ten years was a fool." He made a $10,000 loan to Henry Clay Frick that resulted in the Frick Coke Company. (Carnegie Library of Pittsburgh.)

Third National Bank, located at the corner of Oliver Avenue and Wood Street, was organized in 1864. The Beaux-Arts building was designed by Daniel Burnham. First Presbyterian Church (back, left) was originally built on Wood Street in 1853. In 1905, industrialist Henry Oliver, who owned the land, decided Sixth Avenue would be a better location and rebuilt the church at its present site. (Carnegie Library of Pittsburgh.)

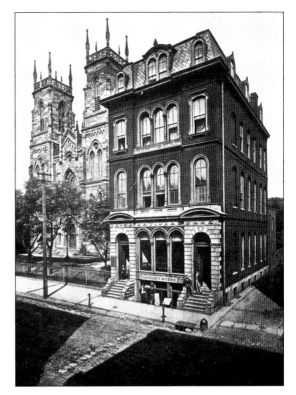

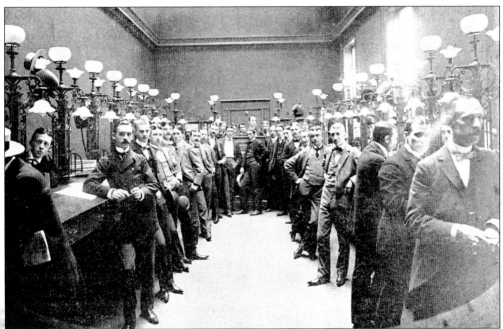

Each banker in this image represents a different bank during the busy hour at the Pittsburgh Clearing House in the 1890s. Before mergers, the city had some 30 independent banks. The clearinghouse was where the banking business was transacted. The banking business grew from $786,000 in 1890 to $1,615,000 in 1900. (Carnegie Library of Pittsburgh.)

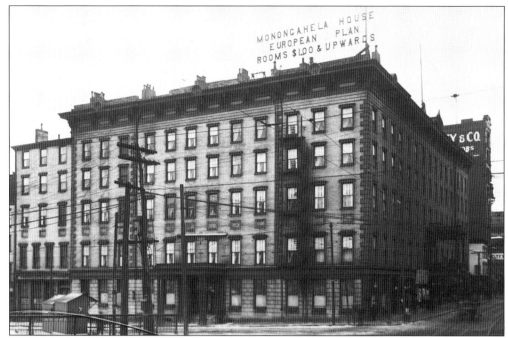

The Monongahela House was built in 1893 as Pittsburgh's premier hotel. It was located on Smithfield Street between First Avenue and Water Street. It was described as "beautifully located on the banks of the Monongahela River, convenient to the steamboat landing." It was destroyed by the great fire in 1845 and rebuilt (seen here) with five stories, 200 rooms, and a banquet hall that could accommodate 1,500 people. (Carnegie Library of Pittsburgh.)

Guests of the Monongahela House have included presidents John Quincy Adams, Andrew Jackson, Zachery Taylor, William Harrison, Abraham Lincoln, Ulysses S. Grant, James Garfield, Grover Cleveland, Theodore Roosevelt, William McKinley, and Howard Taft. Other guests included William Jennings Bryan, Charles Dickens, Mark Twain, Henry Clay, Jenny Lind, Henry Ward Beecher, Edwin Booth, Buffalo Bill Cody, and King Edward the VII. It was torn down in the early 1920s. (Carnegie Library of Pittsburgh.)

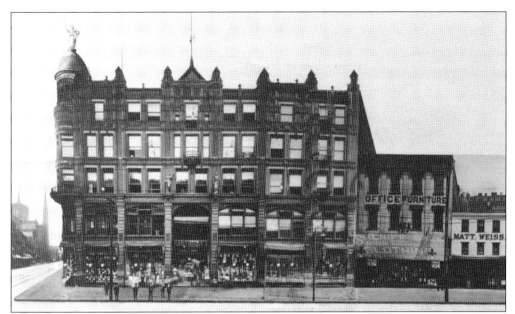

Morris, Henry, Jacob, and Isaac Kaufmann arrived in Pittsburgh from Germany around 1860. By 1871, Kaufmann Brothers was a flourishing tailoring business in a one-room location on the South Side. In 1874, they moved their clothing business to Federal Street in Allegheny. In 1887, they built this building on Smithfield Street and Fifth Avenue in downtown Pittsburgh to sell clothing and dry goods. (Carnegie Library of Pittsburgh.)

Trolley and wagon traffic moves in front of Kaufmann's new building at its present site on Smithfield Street in 1899. The current building was designed by Charles Bickel in Romanesque and classical revival style. In 1913, Morris's son Edgar took over the store, and under his leadership, Kaufmann's not only became a Pittsburgh landmark, but also one of the largest and best-known department stores in America. (Carnegie Library of Pittsburgh.)

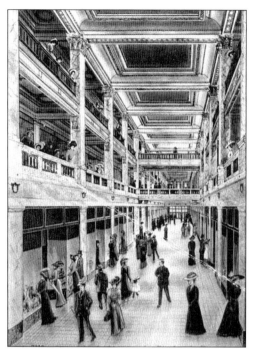

In 1864, Thomas C. Jenkins built a six-story warehouse at the corner of Fifth and Penn Avenues. When it burned down in 1897, his heirs built a large arcade complex in its place called the Jenkins Arcade. It uniquely offered a variety of specialty shops and restaurants under one roof. It was demolished in 1983 and is now the site of Fifth Avenue Place. (Carnegie Library of Pittsburgh.)

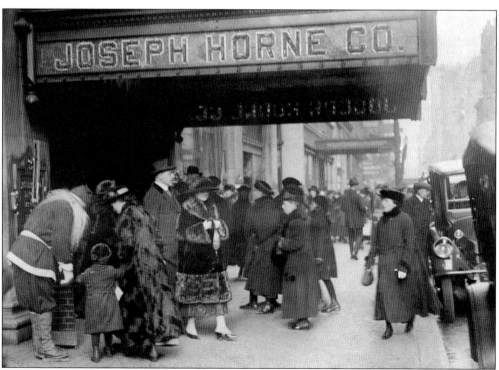

Joseph Horne and Company on Stanwix Street and Penn Avenue was built in 1892. The brass windows at ground level were a result of the St. Patrick's Day flood of 1936. Brass plates could be fitted over the windows to create a vacuum to keep the water out. At Christmas, families would come to see Santa and the moving window displays. (Carnegie Library of Pittsburgh.)

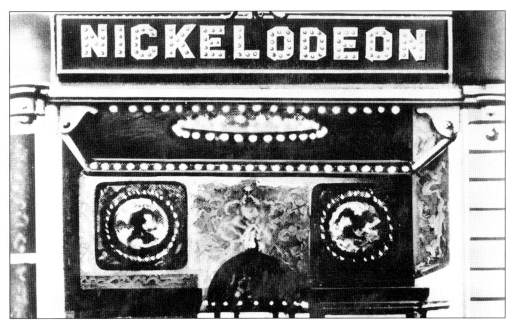

The first moving picture theater in America was the Nickelodeon on the 400 block of Smithfield Street. It opened on October 19, 1905. The name Nickelodeon combined the price of admission with the ancient Greek name for theater, *odeon*. It opened at 8:00 a.m. and closed at midnight. Up to 7,000 people attended 70 shows each day in the 100-seat theater. Moviegoers marveled at the "slow motion" movement of a hummingbird's wings. (Carnegie Library of Pittsburgh.)

In the early years of downtown Pittsburgh, stage shows were not accepted by the upper class as a permissible genre of public entertainment. By 1833, mores had changed and the Pittsburgh Theatre opened on Fifth Avenue near Wood Street. It was better known as the "Old Drury." It was torn down in 1870. The upper floor was a false facade. (Carnegie Library of Pittsburgh.)

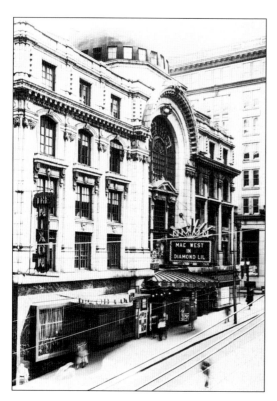

The Nixon Theater was known as the world's "Perfect Theater." It opened on December 7, 1903, and closed in April 30, 1950. It was demolished to make way for the Alcoa Building on Sixth Avenue. This 1909 marquee reads, "Mae West in Diamond Lil." (Carnegie Library of Pittsburgh.)

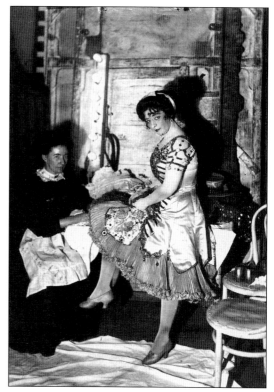

This backstage dressing room image of the Nixon Theater shows a Follies Girl being attended to by an assistant in 1908. (Carnegie Library of Pittsburgh.)

When Loews Penn Theater on Sixth Street was built in 1927, during the glory days of the movie industry, it was one of the most elaborate movie palaces in the country. The last production in the old theater was *Hello Dolly* with Carol Channing in 1967. Eventually the entire block was purchased for the development of the Heinz Hall for the Performing Arts. (Historical Society of Western Pennsylvania.)

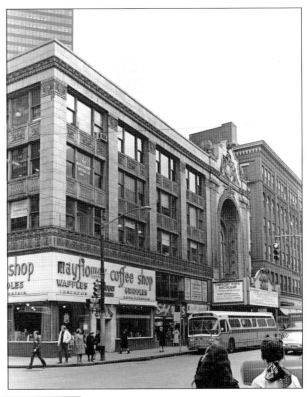

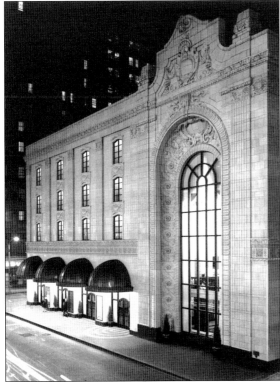

The Heinz Endowment saved the Loews Penn Theater after it closed. It was remodeled as the Heinz Hall for the Performing Arts. The building contains the original 1927 imported Italian marble and two 15-foot chandeliers weighing a ton each that hang in the Grand Lobby. The grand opening of Heinz Hall was September 10, 1971. The 2,661-seat hall is now the home of the Pittsburgh Symphony Orchestra. (Historical Society of Western Pennsylvania.)

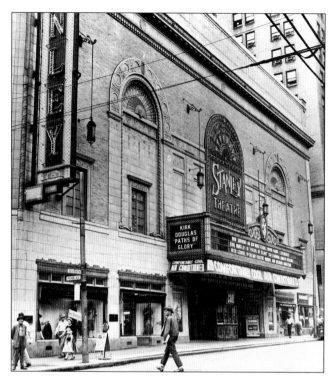

The Stanley Theatre, at the corner of Penn Avenue and Seventh Street, was built in 1927 for $3 million and attracted such stars as Al Jolson, the Marx Brothers, George Burns, Gracie Allen, Mickey Rooney, Frank Sinatra, Dean Martin, Jerry Lewis, Judy Garland, and Nat King Cole. Opening night featured the silent film *Gentlemen Prefer Blondes*. It is now the 3,000-seat Benedum Center for the Performing Arts and home of the Pittsburgh Opera. (Carnegie Library of Pittsburgh.)

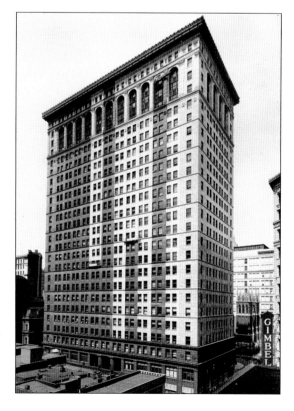

Henry Oliver grew up with Andrew Carnegie in Old Allegheny (North Side). Oliver made millions when he brought high-grade iron ore from the Mesabi Range of Minnesota to Pittsburgh. When he died in 1904, his family built a 24-story office building in his honor at the corner of Smithfield Street and Sixth Avenue. In this image, the landmark building is being cleaned of smoke stains in 1956. (Historical Society of Western Pennsylvania.)

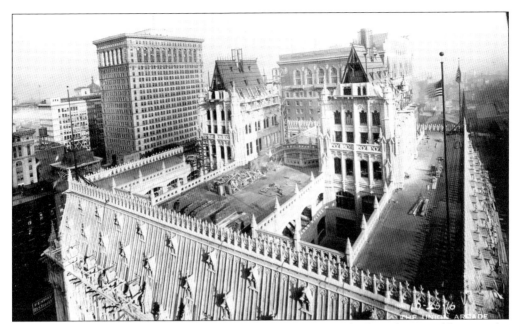

This 1916 image of the Frick Building on Grant Street, with the Oliver Building in the background, was the largest arcade in the world at the time. The 11-story Flemish Gothic building was constructed by Henry Clay Frick in 1916 and had 240 retail shops and 700 offices. In 1922, it became the Union Trust Building. The chapel-like towers on the roof house elevator equipment. (Archives Service Center of the University of Pittsburgh.)

The Wabash Terminal was one of five major railroad terminals in downtown Pittsburgh. Jay Gould built the terminal on Liberty Avenue in 1904. It was the largest Beaux-Arts building in the city and one of the most magnificent railroad terminals in America. "Gould's Folly" went into receivership four years later, and it was used as office space for most of its existence. It was demolished in 1955. (Historical Society of Western Pennsylvania.)

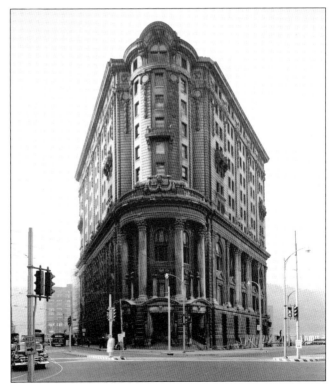

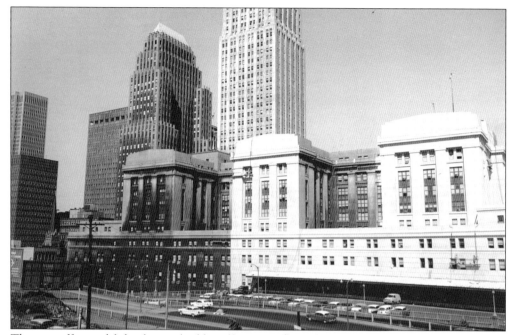

The post office and federal court building (foreground) on Grant Street at Seventh Avenue were opened in 1932. The limestone buildings cost $8 million to construct. Behind it are the Koppers Building (left) and Gulf Building (right). The 34-story Koppers Building opened in 1929 in the art deco style and was made with a copper roof. (Historical Society of Western Pennsylvania.)

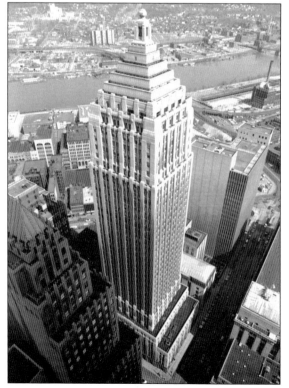

Built in 1930, the 41-story Gulf Building is located at Grant Street and Seventh Avenue. On the top of the building are neon tubes that predict the weather. Steady blue is rain and rising temperatures, flashing blue is rain and falling temperatures, steady orange is clear and rising temperatures, and flashing orange is clear and falling temperatures. The Koppers Building is to the left. (Historical Society of Western Pennsylvania.)

Six

IMMIGRANTS AND INDUSTRY

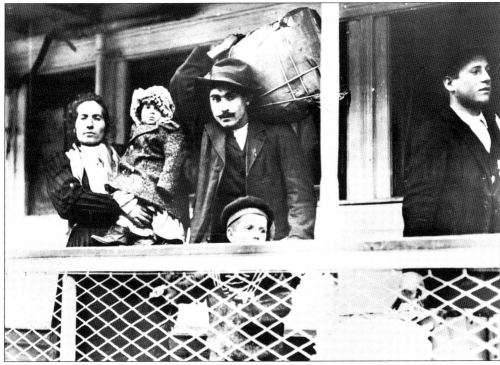

The story of Pittsburgh is the story of European immigration and the Industrial Revolution. One fueled the other. Without the immigrants there would have been no mills, and without a place to work the immigrants would have never come. Between 1892 and 1924, 12 million immigrants passed through Ellis Island. Most of them never set foot in New York City. They left on trains or boats as quickly as they arrived to find work in the mills and factories. They carried their family belongings on their backs. Shipload after shipload of immigrants arrived because the mills needed workers. They changed Pittsburgh from an agricultural hub into an industrial center. Agents of the mills went through the villages of Europe, convincing families to sign contracts that secured them passage to Pittsburgh and a place in the mills. Andrew Carnegie placed a value of $1,500 on each adult because "in former days an efficient slave sold for this sum." (Carnegie Library of Pittsburgh.)

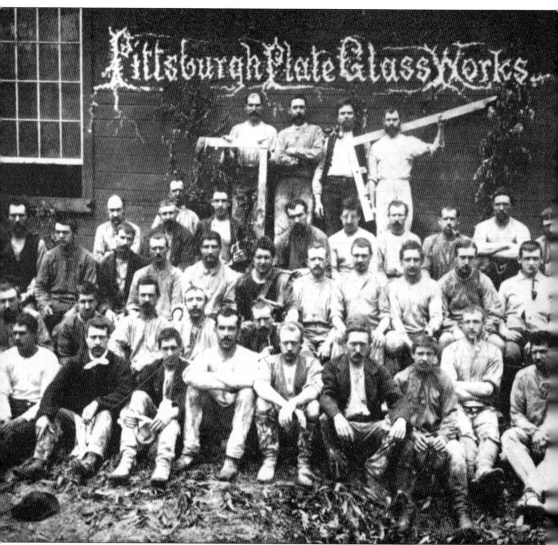

The first industry in Pittsburgh was the production of glass. In the mid-1800s, Pittsburgh was known as the "Glass Capital of America." At the height of the industry there were nearly 80 glass factories operating out of Pittsburgh. Presidents Andrew Jackson and James Monroe ordered glass tableware for the White House from Pittsburgh. Gen. James O'Hara and Maj. Isaac Craig were the pioneers of the glass industry. In 1797, they opened a glass factory on the South Side near the present-day Duquesne Incline parking lot. The basic ingredients of glass are sand, which came from the sandbar in the middle of the Monongahela River, and potash, which came from wood ash and lime from limestone quarries where it was crushed into fine powder. This is a group of Pittsburgh Plate Glass Company employees in Cheswick in 1887. The company was founded in 1883 by John Pitcairn and Capt. John B. Ford. (Carnegie Library of Pittsburgh.)

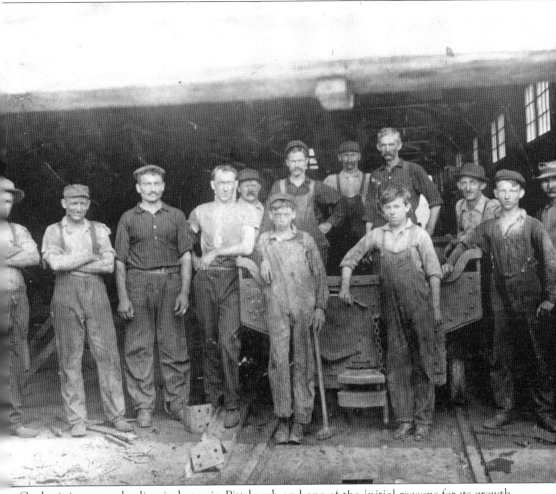

Coal mining was a leading industry in Pittsburgh and one of the initial reasons for its growth. Bituminous coal fueled the iron and steel industry. Young immigrant boys started work in the mines between the ages of 9 and 12, as seen in this 1909 image of the car shop crew of the Vesta mine No. 4 in Richeyville. The mine was owned by J&L Steel Company and provided coal to its mills along the Monongahela River. The Vesta mine was the largest bituminous coal mine in the world. It contained over 100 miles of track. Each trip of loaded cars carried 500 tons of coal. The mules that pulled the coal cars were stabled in barns below the surface of the mine. Initially the mills got their coal from Mount Washington. In 1914, 85 percent of the immigrants could not speak or read English, placing them at a terrible disadvantage in moving beyond their present living conditions. They did their shopping at the company store, which made the workers indentured servants to the company. (Historical Society of Western Pennsylvania.)

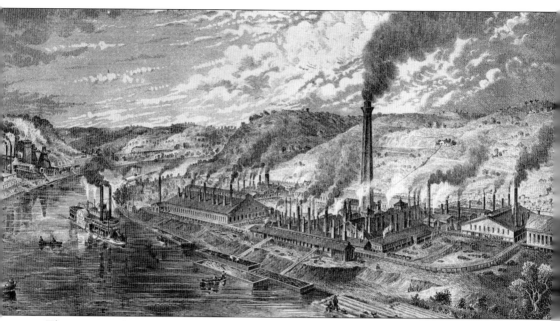

This is an 1875 engraving of the American Iron Works founded in 1853 by German immigrant ironmasters John and Bernard Lauth. Four months after the founding, they established a partnership with B. F. Jones, and in 1856, James Laughlin, a prominent Pittsburgh banker; the partnership became the Jones and Laughlin Company. During the American Civil War the company prospered by supplying iron to the Union army. After the war, iron was in demand during the railroad boom that fueled the expansion of America. Pittsburgh was known worldwide as the center of the iron and steel industry and was the capital of the Industrial Revolution. The immigrants made its growth and prosperity possible. Because Pittsburgh was the first city west of the Allegheny Mountains, it quickly became the center of industry, manufacturing, and shipping from the east, down the Ohio River to the Mississippi River and New Orleans. (Historical Society of Western Pennsylvania.)

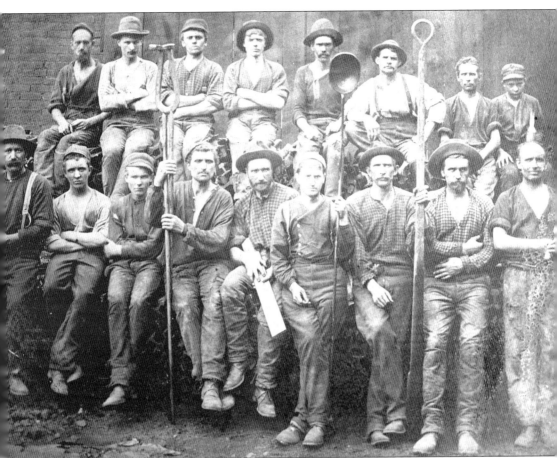

These workers are posing with their tools at the Jones and Laughlin Mill on August 30, 1908. Some of them are holding puddling rods to open the red-hot furnaces. Mill workers had one holiday a year on the Fourth of July and were paid a wage of $2 per day. A typical shift was 12 hours long, seven days a week. They came to Pittsburgh to make steel for the factories of the Industrial Revolution and, most importantly, for the railroad tracks that would stretch across the country like a giant spiderweb. Thomas Bell wrote in his 1941 book, *Out of this Furnace*, about immigrants who came to Pittsburgh that these were the people who "with their blood and lives helped to build America, that the steel they produced changed the United States into the most industrialized nation in the world." (Historical Society of Western Pennsylvania.)

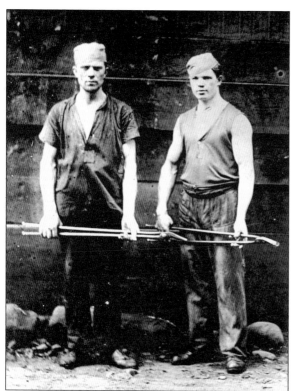

The caption of this 1917 image reads, "l-r Stanley Tanski, Stanley C. Ankowski. Ankowski started at J&L in 1915 as a rougher and was a roller on #26 Mill from 1924 to 1939." (Historical Society of Western Pennsylvania.)

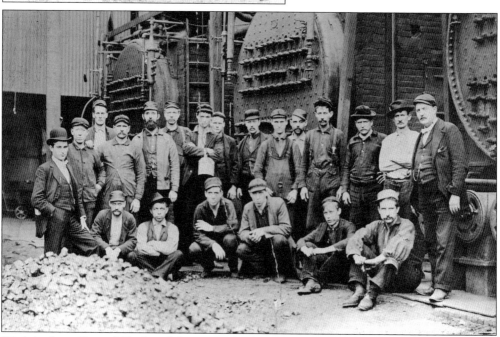

Work in the mill was difficult and dangerous for the J&L Eliza Furnace Boiler House Crew shown here in 1894. Workers began organizing against inadequate conditions and pay in the 1880s. Until then, strong-arm tactics blocked workers' attempts to organize. Management could blackball a worker if his attitude was bad toward the company. (Historical Society of Western Pennsylvania.)

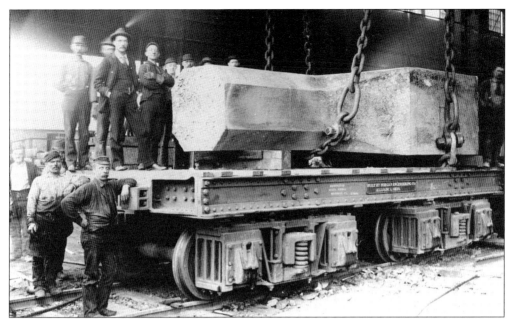

Workers use an overhead crane to place a massive 90-ton ingot on a flatbed train car in 1895. A strike in 1897 at the Carnegie Mill in Homestead resulted in a short-lived workers contract. Three years later, the mill cut wages and the workers went on strike again. The company hired 300 Pinkerton agents to break the strike. After a fierce battle, seven workers were killed. (Archives Service Center of the University of Pittsburgh.)

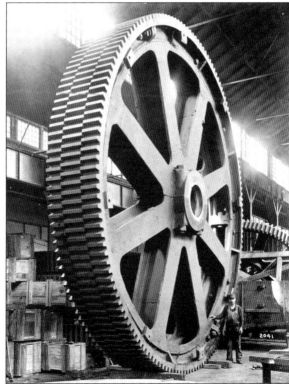

A Mesta Machine employee stands next to an enormous molded staggered-tooth gear at the company factory in 1913. Workers had few rights and little control over their destiny. It was not until 1936 that the Steel Workers Organizing Committee was organized in Pittsburgh with 125,000 workers in 154 lodges. Eventually the organization became one of the most powerful unions in the world, the United Steel Workers AFL-CIO. (Carnegie Museum of Art.)

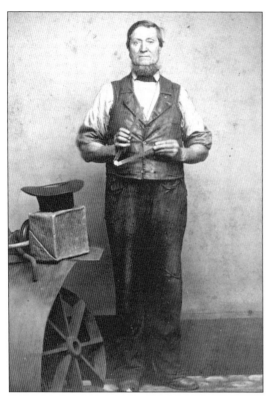

Between 1860 and 1867, the Sligo Iron Works did something unique. They had the Cargo Photographic Company take pictures of their employees. Photography was still in its early stages of development. James Young worked as a millwright who built and repaired mill machinery. He lived on Carson Street in the South Side. At this time, Sligo had 30 employees. By 1879, the company employed 250 men and had 25 puddling furnaces. (Historical Society of Western Pennsylvania.)

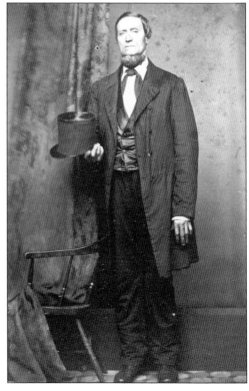

This is Young in his best clothes, or ones borrowed from the photographer, for an image to send home to family and relatives. Unskilled laborers were paid $12–$15 per week. It was difficult for an immigrant worker to save money because every penny was needed for food, rent, fuel, and clothing. Mill accidents were frequent and could reduce a family to poverty. (Historical Society of Western Pennsylvania.)

M. Meyers Jr. worked for Sligo Iron Works as a "pull up." His primary responsibility was to pull up the doors of the puddling furnaces. Most boys entered the mills as full-time laborers between ages 9 and 12. Very few had schooling beyond the third grade. Meyers's primary goal was to learn to read and write in English so he could be classified as literate. (Historical Society of Western Pennsylvania.)

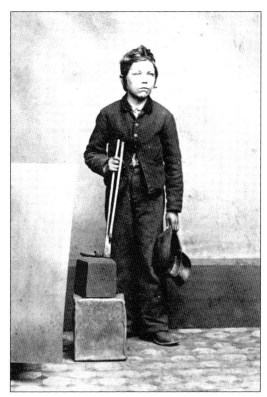

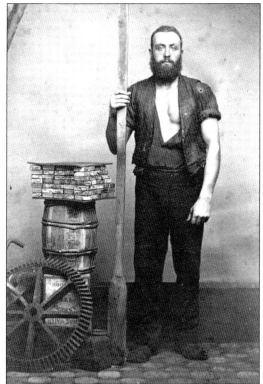

Adam Hart was a "heater" at a bar mill. He took muck bars of iron that were unfinished and loaded them into a furnace for refinement. It was a difficult task to make certain the iron bars reached the correct temperature and were removed at the right time. Because of the skill required, heaters were among the best-paid workers in the mill. (Historical Society of Western Pennsylvania.)

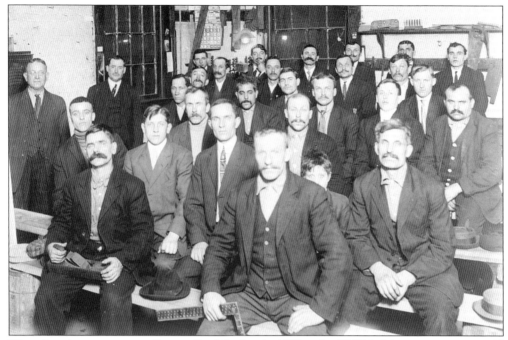

These immigrants are attending an English class in 1913 at the YMCA. Most immigrants could not speak, read, or write English, placing them at an enormous disadvantage in improving their living conditions in America. (Carnegie Library of Pittsburgh.)

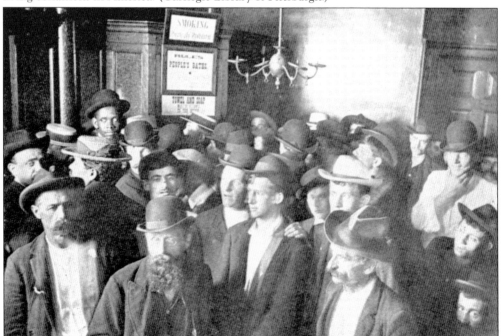

This 1907 image shows the first Peoples Bath House in the city of Pittsburgh. It was built in 1897 on Sixteenth Street and Penn Avenue. Because there was no running water, the only way to keep clean was to visit a public bathhouse. The hours of the bathhouse are written in four languages. "Women's Day" is noted on the window. (Carnegie Library of Pittsburgh.)

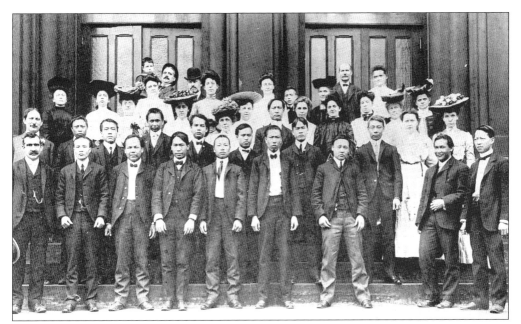

This is a group of Chinese immigrants on a Sunday afternoon in 1900 at the Ross Street entrance to the First Baptist Church, now the present site of the City-County Building. They are attending a class taught by Irish-born church member Jessie Collins Gormley and her friends. It is probably a class to read and write English. (Carnegie Library of Pittsburgh.)

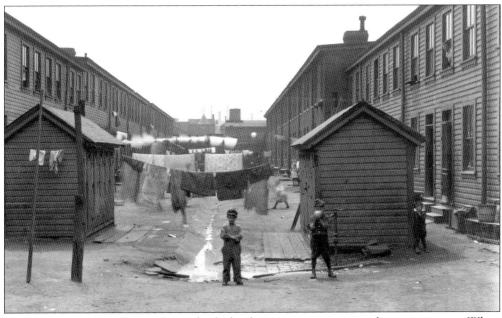

This 1921 row house image shows the lack of sanitation, sewage, and running water. When the immigrants arrived, there was a scarcity of housing, insufficient fire and police protection, and only a handful of health facilities. Crowded tenements were a recurring cause of dreadful epidemics. Buckets were used to carry contaminated water to the apartments, and families shared the same outhouses. (Archives Service Center of the University of Pittsburgh.)

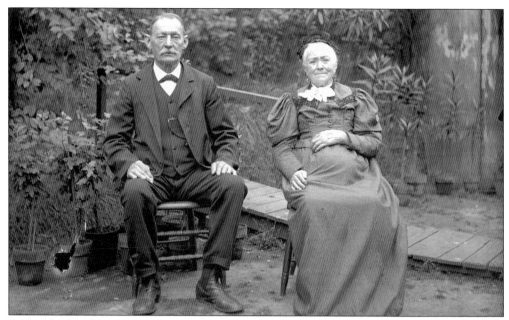

Frederick Theodore Wagner was a Pittsburgh photographer who often took pictures of his family and friends. Many of his pictures show immigrant families in their later years. These are his parents, August and Elizabeth Wagner, who came to America from Germany in 1904. August worked for the railroads as a clerk at Union Station, and he died on October 22, 1956. (Historical Society of Western Pennsylvania.)

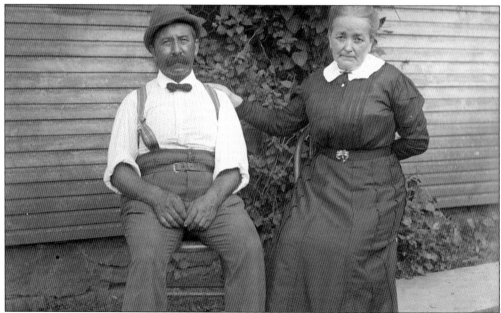

Wagner took this image of Mr. and Mrs. Kunkel on July 4, 1911. Immigrants were the heart of the city. Within a single generation Pittsburgh became known as the Workplace of the World. It supplied the railroads with rails and locomotives, factories with machinery, telegraph and electric companies with wires, and the tools and equipment for the farms that fed the country. (Historical Society of Western Pennsylvania.)

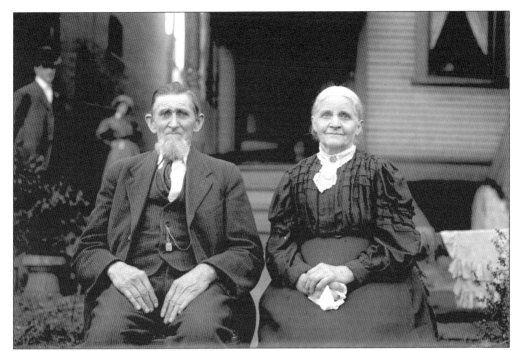

Wagner took this image of "Mrs. Megoneys parents" on October 26, 1907. When Horatio Alger Jr. wrote his rags-to-riches stories in the late 1800s, he convinced second-generation immigrants, like these shown here, that they could become prosperous through hard and industrious work. (Historical Society of Western Pennsylvania.)

Wagner took this image of "Mr. and Mrs. Megoney," on October 26, 1907. By this time, Pittsburgh had become the true melting pot of America. Between 1880 and 1900, the foreign-born population doubled. (Historical Society of Western Pennsylvania.)

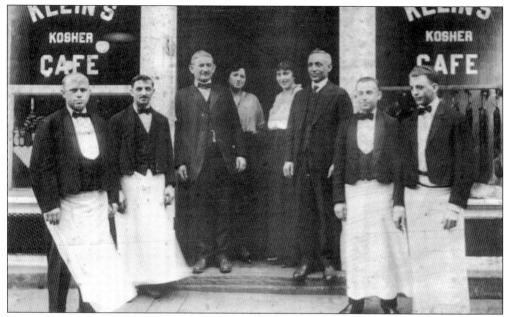

Klein's Kosher Café was founded in 1900 by Joseph and Hanna Klein, who came to America from Austria-Hungary. They built a small delicatessen on Penn Avenue in downtown Pittsburgh. The family restaurant featuring seafood relocated four times, the last at 330 Fourth Avenue. The original Klein's Restaurant sign can be seen at the Heinz Regional History Center in the Strip District. The restaurant closed in February 1992. (Historical Society of Western Pennsylvania.)

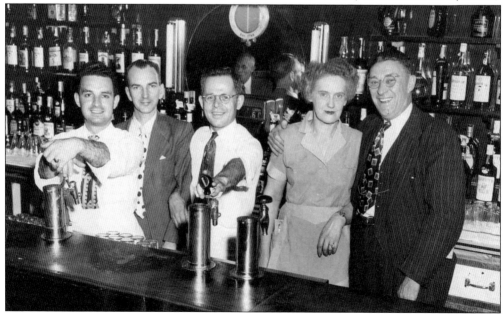

From the end of Prohibition in 1933 until his death in 1966, Pete Palafoutas (center), part of a large Greek immigrant community, owned a series of small restaurants downtown. The Green Mill, pictured here in 1949, was located where the Gateway Center is now. The Pittsburgh Renaissance dislocated the restaurant to Market Square where Palafoutas opened the Triangle Bar and Grill. He was characteristic of the immigrants who built Pittsburgh.

Seven

GETTING OVER AND GETTING AROUND

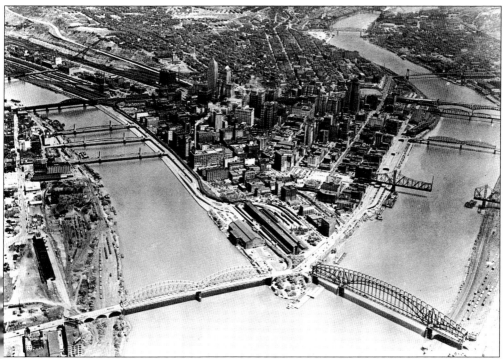

Because of its location, the primary challenge of living in Pittsburgh was getting over the rivers and getting around the hills. Before the first bridge was built in 1818, the only means of travel across the rivers was by ferry or wading. Before the construction of the dams around 1900, the Monongahela River was shallow enough to wade across in the summer. In 1948, along the Monongahela River (right) are the Point Bridge, Wabash Bridge (being dismantled), Smithfield Street Bridge, Pan Handle Bridge, Liberty Bridge, and Tenth Street Bridge. Along the Allegheny River (left) are the Union Bridge, Three Sister Bridges (Sixth, Seventh, and Ninth Streets), and Fort Wayne Railroad Bridge. There are over 440 bridges in the city of Pittsburgh, more than Venice, Italy. (Carnegie Library of Pittsburgh.)

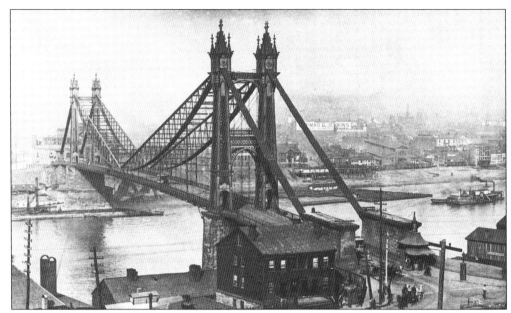

The Point Bridge over the Monongahela River connected the Point to an area near the Duquesne Incline on the South Side. Built in 1877 as a chain suspension bridge by the American Bridge Company, the cables were drawn through 110-foot towers and joined at the center of the bridge. It was replaced by a new bridge in 1927 that was torn down in 1959 to make way for the Fort Pitt Bridge. (Carnegie Library of Pittsburgh.)

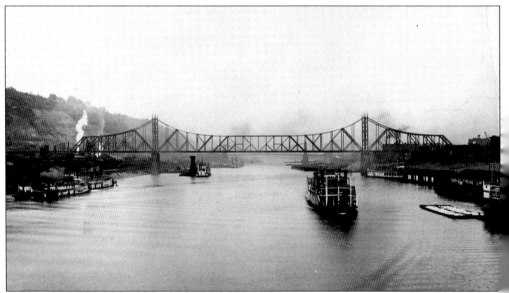

The Wabash Railroad Bridge over the Monongahela River was built by Jay Gould in 1904 to challenge the near monopoly of the Pennsylvania Railroad. It led to the Wabash-Pittsburgh terminal on Liberty Avenue. In 1948, the company went bankrupt and the superstructure was removed. The piers are still in place near Stanwix Street. The steamers *Alice Brown* and *Raymond Horner* can be seen approaching the Wabash Bridge in 1912. (Carnegie Museum of Art.)

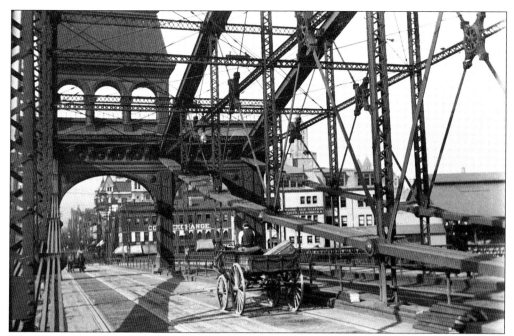

The first bridge in Pittsburgh was a covered wooden toll bridge built in 1818 at the present site of the Smithfield Street Bridge. It crossed 1,200 feet of river at Smithfield Street. Before the bridge was built, all traffic passed from one side of the river to the other by ferry. This is an image of the Smithfield Street Bridge in 1911. (Carnegie Library of Pittsburgh.)

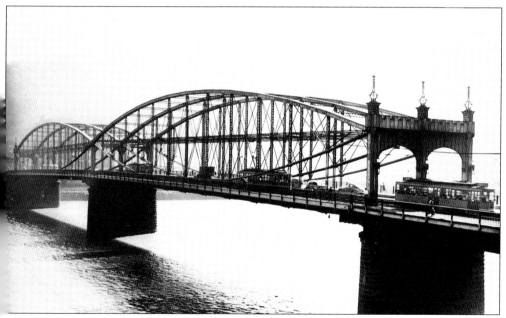

n 1845, the great fire of Pittsburgh burned the original Smithfield Street Bridge to ashes in .0 minutes. John Augustus Roebling, who later designed the Brooklyn Bridge, rebuilt the bridge n 1846 as a suspension bridge. Roebling's bridge was demolished in 1883 and redesigned as a enticular bridge by Gustav Lindenthal in 1884 (shown here). (Carnegie Library of Pittsburgh.)

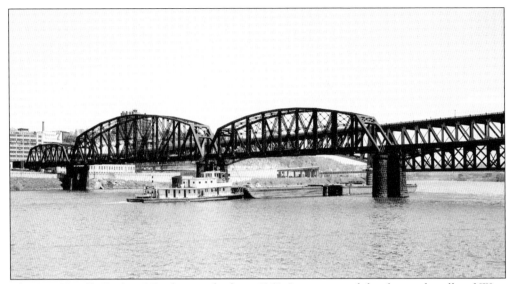

The Pan Handle Railroad Bridge was built in 1861. It was named for the panhandle of West Virginia where the railroad entered western Pennsylvania. It was replaced in 1903. In 1989, it became part of the Pittsburgh Light Rail, known as the "T." (Archives Service Center of the University of Pittsburgh.)

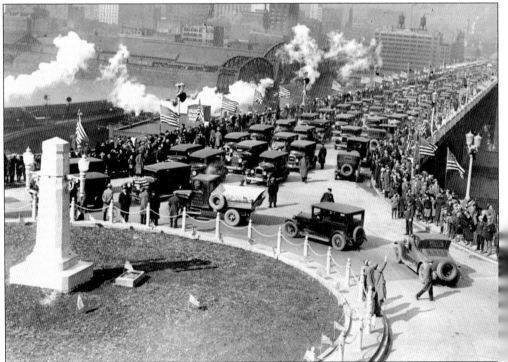

On March 27, 1928, after nine years of work, the $9.4 million Liberty Bridge and Tunnels were opened. For the next 90 minutes, a mile-long procession of automobiles streamed across the bridge to the first direct link with the South Hills. Property values in the South Hills immediately skyrocketed. At the time, the tunnels were the largest vehicular tubes in the world, measuring over a mile in length. (Carnegie Library of Pittsburgh.)

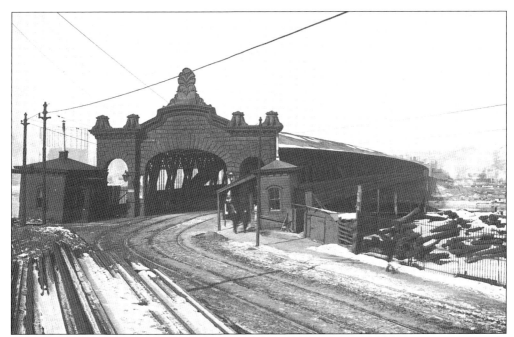

The covered wooden Union Toll Bridge across the Allegheny River at the Point was a privately built toll bridge, which opened in 1874. Shown here is the entrance to the bridge at the Point with trolley tracks leading through the bridge after a snowfall. (Carnegie Library of Pittsburgh.)

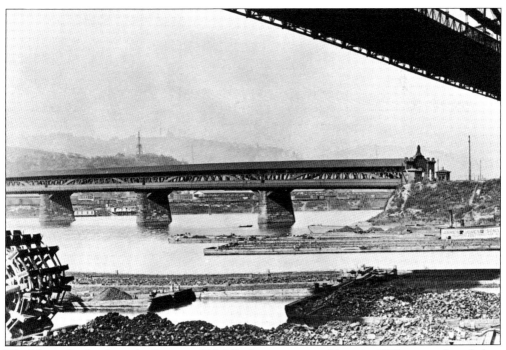

The Union Bridge from the Point to Old Allegheny is pictured here in 1895 as seen from below the Point Bridge across the Monongahela River. It was torn down in 1907 and replaced by the North Side Point Bridge known as the Manchester Bridge. (Carnegie Library of Pittsburgh.)

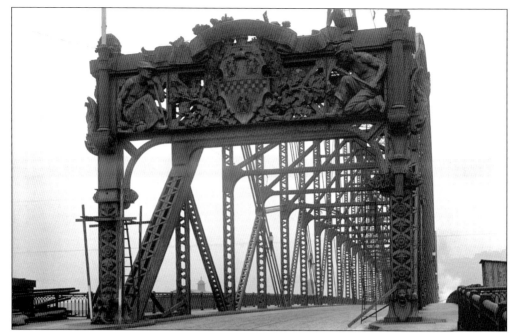

This is the north portal of the Manchester Bridge that replaced the Union Bridge. Construction began in 1911 and was completed in 1913. Joe Magarac, the mythological steelworker, was sculpted into the portal. (Archives Service Center of the University of Pittsburgh.)

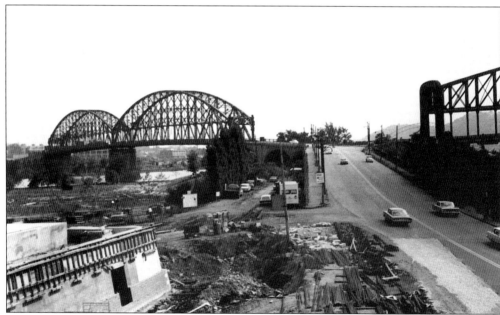

This is a view of the Manchester Bridge (right) to the North Shore and Old Allegheny in 1965. Traffic patterns were narrow, congested, and confining at the Point. The Manchester Bridge was demolished in 1969 to make way for the Fort Duquesne Bridge, which for a period of time was known as the "bridge to nowhere" because its north end was not connected until Interstate 279 was built. (Carnegie Library of Pittsburgh.)

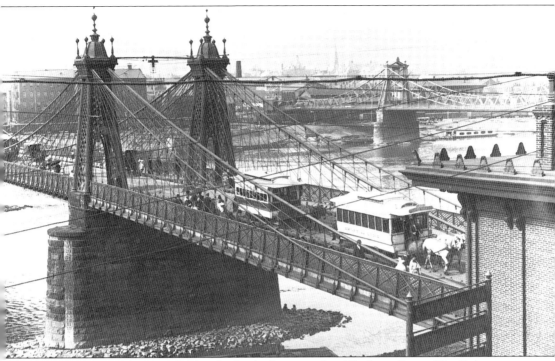

The Sixth Street Bridge was the first bridge built across the Allegheny River. The Robinson family operated a ferry across the river and eventually constructed a wooden toll bridge at Sixth Street. When horse-drawn trolleys required a stronger bridge, a multispan suspension bridge (seen here) was built in 1859 by John A. Roebling, designer of the Brooklyn Bridge. The main cables were 22 feet apart, 7.5 inches in diameter, and composed of seven strands of 700 wires each. A third bridge was built in 1892, capable of handling electric trolley cars. When the present Sixth Street Bridge was built in 1924, the bridge was lowered onto barges and floated down the river to Neville Island where it was reconstructed on piers to span the Ohio River in Coraopolis. (Carnegie Library of Pittsburgh.)

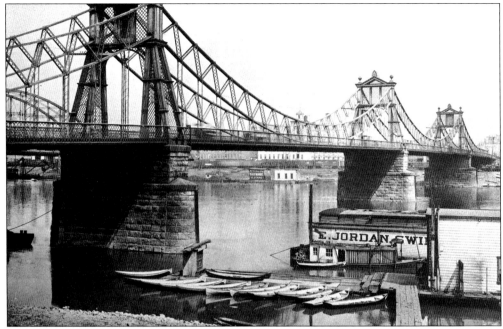

This is an 1893 view of the Seventh Street Bridge, designed by Gustav Lindenthal three years after he designed the Smithfield Street Bridge. It was a two-span suspension toll bridge connecting Seventh Street in Pittsburgh to Sandusky Street in Allegheny City (North Shore). It was replaced in 1926 by a new suspension bridge. (Carnegie Library of Pittsburgh.)

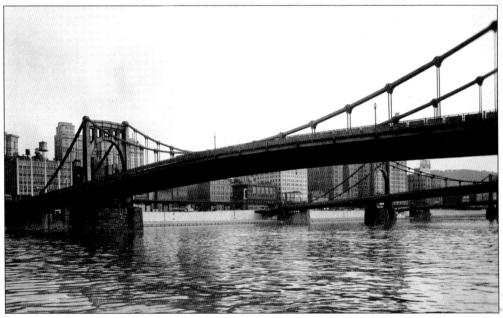

The Ninth Street Bridge was built in 1928 as one of the Three Sisters Bridges (the Sixth Street, Seventh Street, and Ninth Street Bridges). It was part of a massive bridge-building campaign in 1924 that replaced all three bridges. The self-anchored suspension bridge was the first of its type in the United States. (Historical Society of Western Pennsylvania.)

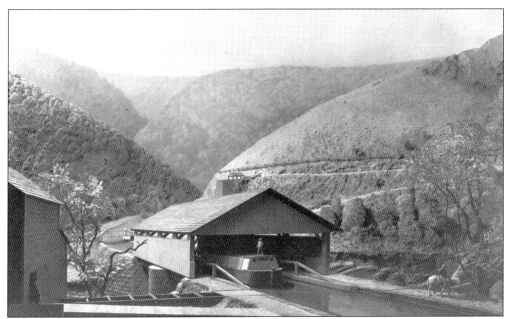

This is the Philadelphia to Pittsburgh canal near Johnstown in 1850. The 350-mile canal journey lasted nearly four days. Charles Dickens, while traveling to Pittsburgh in 1842, remarked he had to "duck nimbly every five minutes whenever the man at the helm cried 'Bridge!' and . . . when the cry was 'Low Bridge,' to lie down nearly flat." (Carnegie Library of Pittsburgh.)

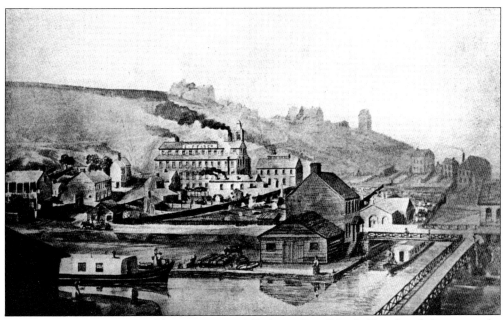

In this 1850 engraving, canal boats arrive at Allegheny City (North Shore) and then cross the Allegheny River via an aqueduct (seen here) to the Pennsylvania Railroad station. Horses pulled the boats along the rivers and across the 1,100-foot-long Allegheny aqueduct. The $25 million canal never paid for itself and was sold to the Pennsylvania Railroad in 1857 for $7 million. (Carnegie Library of Pittsburgh.)

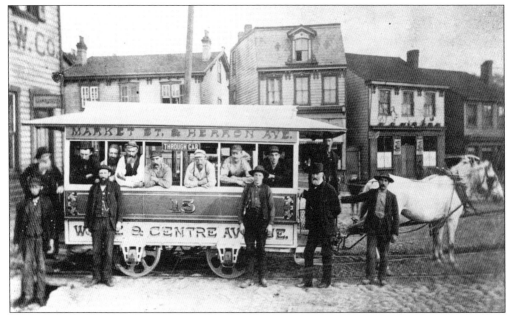

Beginning operation in 1859, horse-drawn trolley cars were the first means of mass transportation in Pittsburgh. The trolley shown in this photograph from 1888 seated 14 passengers and was lit at night by oil lamps at either end of the car. In winter, a thick covering of straw on the floor kept the passengers' feet warm. The driver controlled the speed as the wheels traveled in tracks. Horsecars operated until 1924. (Archives Service Center of the University of Pittsburgh.)

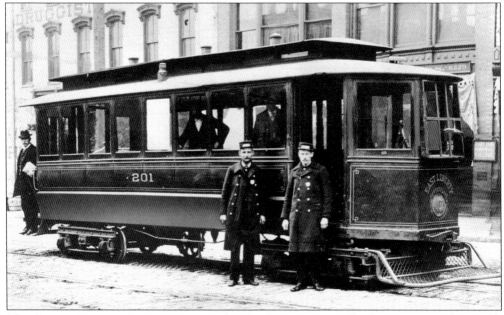

The Citizens Traction Company was Pittsburgh's first traction trolley line, opening along Fifth Avenue in 1889. The traction or grip cars were attached to cables pulled along the tracks that were in a channel beneath the street. A lever engaged the grippers attached to the bottom of the car. Because they were difficult to construct and maintain, they were soon replaced by the electric trolley. (Historical Society of Western Pennsylvania.)

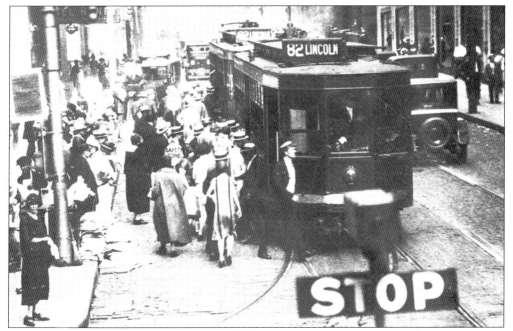

This No. 82 Lincoln Electric Street Railway car is loading passengers along Fifth Avenue. Traffic was controlled by a stop sign. The first electric lines began in 1890. The trolley pole and wheel made contact with the wires overhead by means of a carriage trailing behind the car. (Carnegie Library of Pittsburgh.)

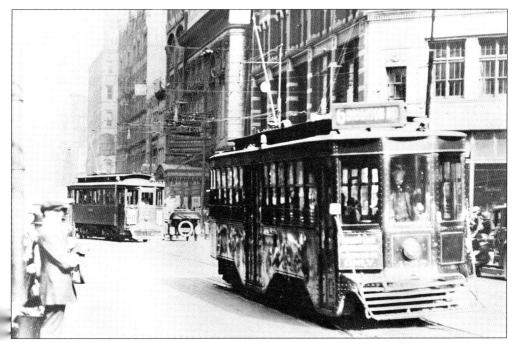

A street railway electric trolley travels down Liberty Avenue in 1900. The electric cars were the primary means of travel around Pittsburgh and to the suburbs. The operator can be seen in the front of the car. (Carnegie Library of Pittsburgh.)

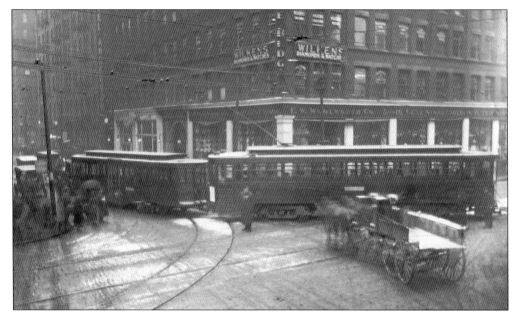

Streetcars, pedestrians, and wagons intersect at the corner of Liberty and Sixth Avenues in 1900 waiting their turn for safe passage. There appears to be a traffic control person in the center of the image. (Carnegie Library of Pittsburgh.)

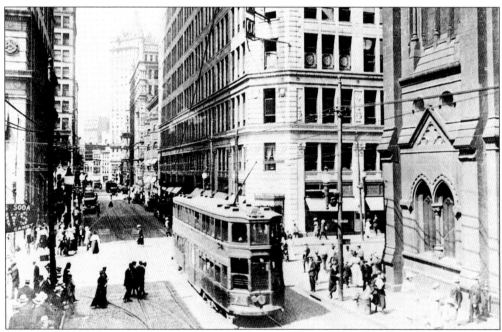

This double-deck trolley on Sixth Avenue in 1910 was one of six Pittsburgh double-deckers, the largest fleet in the country. At the end of Sixth Avenue is the domed Keenan Building that was built in 1907 and is now the Mid-Town Towers. Its base has sculptured portraits of George Washington, William Penn, and Andrew Carnegie. In 1884, Col. Thomas Keenan founded the *Evening Penny*, which became the *Pittsburgh Press*. (Carnegie Library of Pittsburgh.)

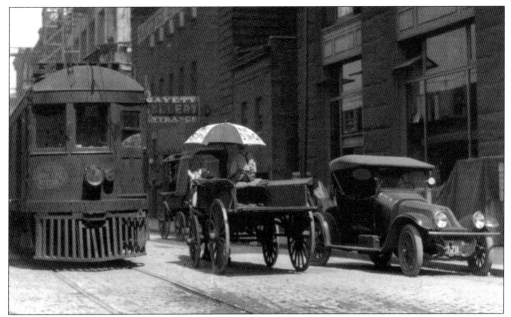

This June 7, 1917, image shows a clash of eras. A streetcar from the Pittsburgh and Butler Shortline, a horse-drawn carriage, and an automobile travel side by side along Liberty Avenue in what is now part of the Cultural District. This was a time of increasing change for the people of Pittsburgh as advances in transportation were rapid and challenging. (Archives Service Center of the University of Pittsburgh.)

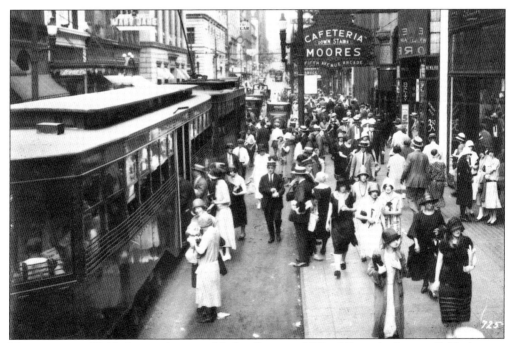

This is a view of Fifth Avenue between Market Street and Wood Street looking up Fifth Avenue during rush hour on July 6, 1925. Straw hats and bonnets were the style in the Roaring Twenties. Passengers are boarding a six-motor, low-floor trolley. (Carnegie Library of Pittsburgh.)

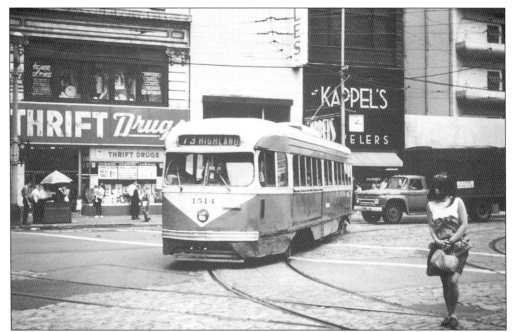

The electric trolley cars turned into what were called streetcars. They were a common means of travel around Pittsburgh. This No. 73 Highland streetcar makes its way along Fifth and Liberty Avenues at 1:15 p.m. in 1969. (Carnegie Library of Pittsburgh.)

Streetcars were a bumpy ride, throwing standing passengers from side to side as they clung to the overhead support bars. The development of the interstates and express highway system leading into Pittsburgh in the 1960s and 1970s dramatically changed the preferred means of transportation from streetcars to the automobile. (Carnegie Library of Pittsburgh.)

Eight

FIRES, FLOODS, RIOTS, AND SMOKE

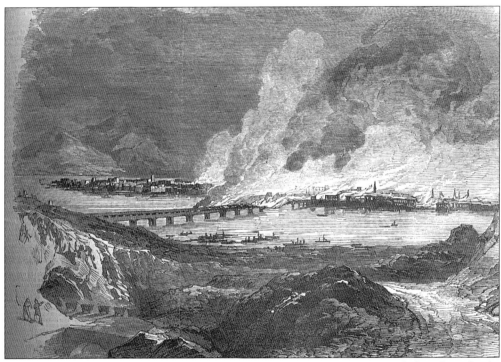

As Pittsburgh grew, it had to overcome sizeable obstacles and disasters, including fires, floods, riots, and pollution. One catastrophe that unexpectedly devastated Pittsburgh was the great fire of 1845. It started at noon on April 10, 1845, in a shed behind the home of Col. William Diehl on Ferry Street. The weather had been very dry without rain for two weeks. The wooden houses were as dry as tinder. High winds spread the fire as it rolled quickly from building to building. By the time the tower bells of the Third Presbyterian Church sounded the alarm, the fire was roaring throughout the city. Attorney Robert McKnight wrote, "A pretty strong wind was blowing from the west and some alarm existed as to the spread of the flames. I mounted an engine and labored with might and main but unfortunately the supply of water failed." The Monongahela Bridge (Smithfield Street) caught fire and was burned to the river in 10 minutes. (Carnegie Library of Pittsburgh.)

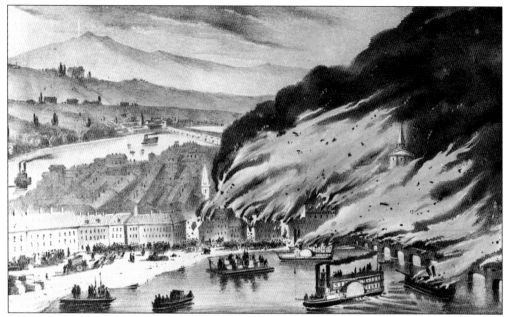

Five hours later when the flames finally died down, two-thirds of the city was destroyed and over 1,200 buildings ruined. The *Pittsburgh Gazette* wrote, "Nothing was spared—very little saved. The progress of the fire as it lanced and leaped with its forked tongue from house to house, block to block, and from square to square was awfully magnificent." The Mon Wharf was covered with personal belongings that were saved from the fire. (Carnegie Library of Pittsburgh.)

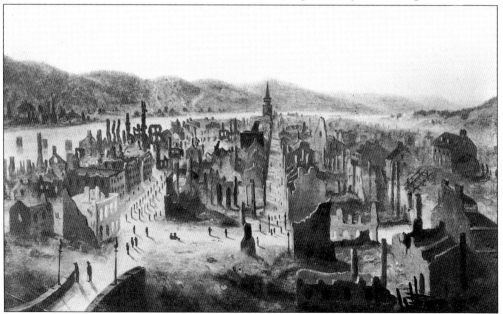

The *Pittsburgh Post* reported, "From an hours walk among the ruins . . . nobody can realize the losses and privitations our citizens have sustained, until he walks through the forest of naked chimneys which mark the path of the destroying element." On Friday the newspaper reported, "the vaults of the Bank of Pittsburgh were opened, and the books, papers, and money were found almost uninjured." (Carnegie Library of Pittsburgh.)

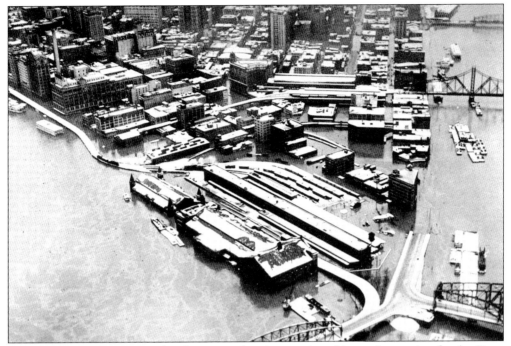

From the days of Fort Pitt the downtown has been vulnerable to destructive floods. Since 1854, the rivers have reached flood stage 112 times. This is a view of the Point during the great St. Patrick's Day flood on March 17, 1936. The rivers at the Point crested at 46.4 feet. Life in Pittsburgh came to a standstill. (Carnegie Library of Pittsburgh.)

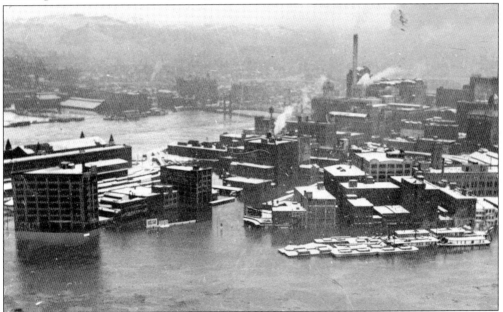

This view of the Point in 1936 shows the roads to the town were submerged and inaccessible. The *Pittsburgh Sun-Telegraph* reported, "Deaths mounted every hour." Over 135,000 people were homeless with an estimated $200 million in damage. After the flood, Congress authorized construction of a network of dams to protect the Ohio River Valley. (Carnegie Library of Pittsburgh.)

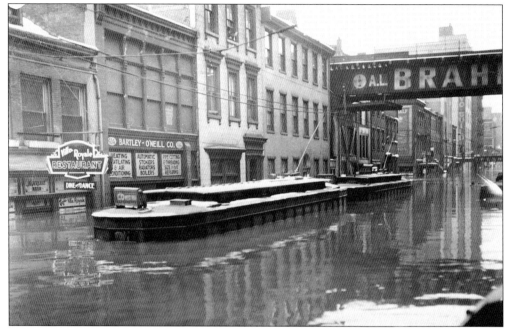

This view of the 400 block of Penn Avenue in 1936 shows transportation was completely immobilized. Streetcars were entirely immersed underwater. It took weeks to get the transportation working again. Stores were flooded, and the city was deserted. (Carnegie Library of Pittsburgh.)

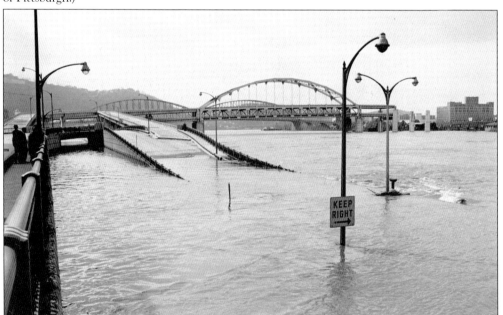

In 1964, a flood struck Pittsburgh with devastating results. Fort Duquesne Boulevard along the Allegheny River (shown here) was completely submerged. The waters of the Ohio River crested at 47 feet. The severity of the flood prompted Pres. Lyndon B. Johnson to declare Pittsburgh a disaster area. Floods remained an annual threat until the completion of the Kinzua flood-control reservoirs on the upper Allegheny River in 1965. (Historical Society of Western Pennsylvania.)

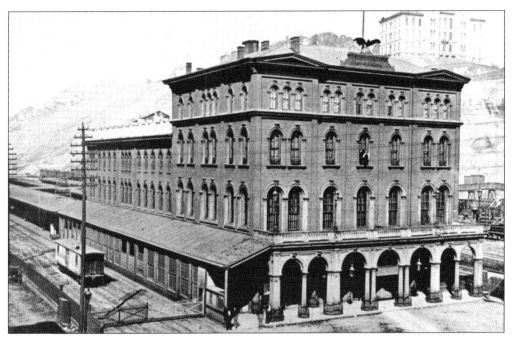

This is a view of the Pennsylvania Railroad Union Depot building on Liberty Avenue before it was destroyed by fire during the Great Railroad Strike of July 1877. The railroad station was built in 1857. On the hill is Central High School (right, background) that was built in 1872 before it relocated to Oakland. (Historical Society of Western Pennsylvania.)

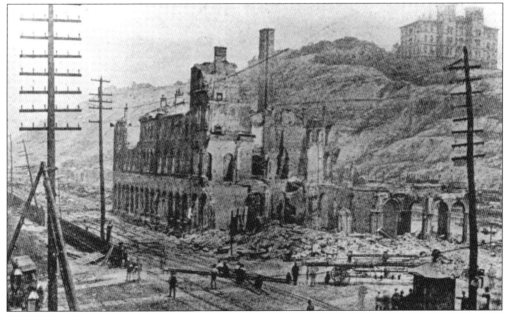

In June 1877, the Pennsylvania Railroad Company reduced its wages by 10 percent and declared all freight trains between Pittsburgh and Derry to be run as a double-headers, or two trains operated by one crew. The workers went on strike, and 650 Pennsylvania Militia were called in from Philadelphia to counter them. In response, the strikers burned the depot to the ground on July 22, 1877. (Historical Society of Western Pennsylvania.)

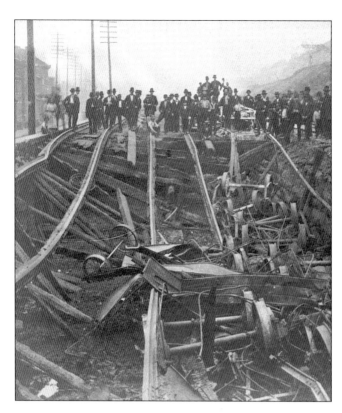

On July 21, 1877, the Pennsylvania Militia tried to disperse a large crowd of strikers. Shots were fired, and 20 people, mostly innocent bystanders, were killed. The crowd began breaking into shops to seize guns and ammunition to fire on the militia. Two days of looting destroyed 1,600 railroad cars and 126 locomotives, and burned 16 buildings, including the Union Depot. (Carnegie Library of Pittsburgh.)

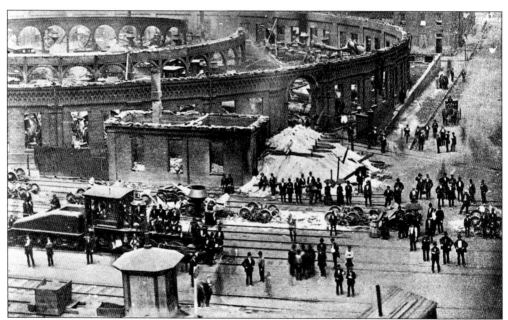

At the time of the strike, railroad workers made an average of $5 a week while dividends for stock owners continued to rise. The Pittsburgh riots were the most violent and destructive the country had ever seen. When the strike was over, the workers won nothing and went back to work. Total damage to the railroad was over $2.5 million. (Carnegie Library of Pittsburgh.)

Air pollution was another great challenge for the city. This image shows the extent of smoke emissions in 1925. As early as 1836, Philip Nicklin, while traveling from Philadelphia to Pittsburgh, wrote that "the country through which you have come is so beautiful, and the town itself so ugly . . . full of good things in the eating and drinking way, but it required much ingenuity to get them down your throat (because of the) smoke and coal-dust." (Carnegie Museum of Art.)

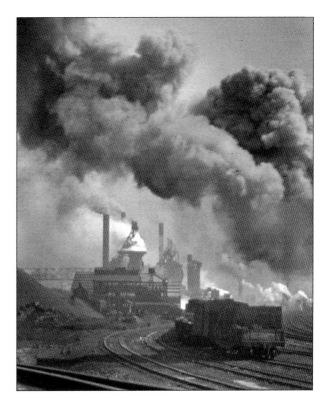

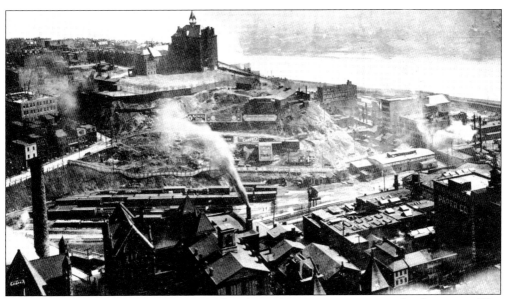

In this view of the bluff overlooking Pittsburgh, smoke is pouring out over the downtown. The image was taken before the construction of the Boulevard of the Allies. The building at the top center is Duquesne University. David Thomas, while traveling through Pittsburgh in 1816, wrote that "dark dense smoke was rising from many parts, and a hovering cloud of this vapor," obscured his view. (Historical Society of Western Pennsylvania.)

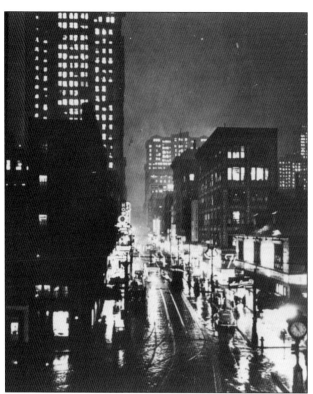

All the buildings have their lights on at 10:55 a.m. at the corner of Liberty and Fifth Avenues in 1940. Pittsburgh was known as the Smokey City. Anthony Trollope wrote in the 1860s, "Pittsburgh . . . is without exception the blackest place I ever saw." In 1868, James Parton wrote in the *Atlantic Monthly*, "Pittsburgh is smoke, smoke, smoke, everywhere smoke, by night it was 'hell with the lid off.'" (Archives Service Center of the University of Pittsburgh.)

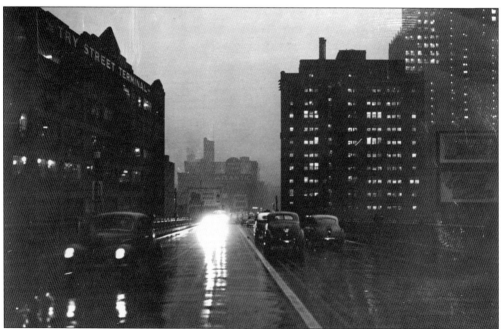

This image of the Boulevard of the Allies in 1944 was taken at 3:00 p.m. Smoke and pollution often caused these night scenes in the middle of the day. Charles Dickens visited the city in 1842 and wrote, "Pittsburgh is like Birmingham in England . . . It certainly has a great quantity of smoke hanging over it." (Historical Society of Western Pennsylvania.)

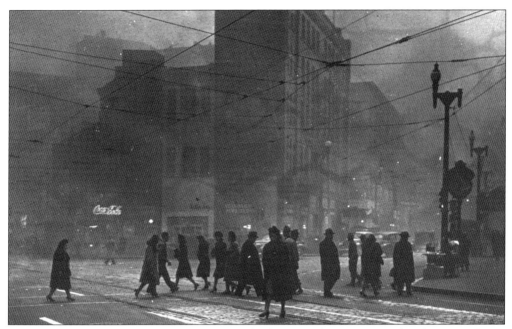

This view of Liberty and Fifth Avenues in the heart of downtown Pittsburgh at 10:35 a.m. in 1940 shows a lighted Coca-Cola sign barely visible in the background. On September 23, 1947, the Allegheny County Board of Commissioners appointed a Smoke Control Advisory Committee to make recommendations for the regulation of the emission of smoke from chimneys and smokestacks. (Archives Service Center of the University of Pittsburgh.)

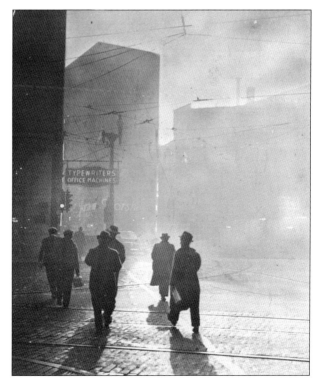

Pedestrians cross Fifth Avenue in 1945. Henry L. Mencken wrote about pollution in Pittsburgh in his book *Prejudices*. "Here was the very heart of Industrial America, the center of its most lucrative and characteristic activity, the boast and pride of the richest and grandest nation ever seen on earth—and here was a scene so dreadfully hideous, so intolerably bleak and forlorn that it reduced the whole aspiration of man to a macabre and depressing joke." (Archives Service Center of the University of Pittsburgh.)

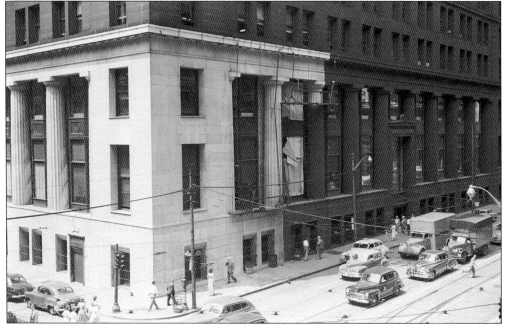

Pittsburgh set an example by removing dirt and grime off the buildings along Grant Street after the smoke emission and pollution laws were passed in 1949. This is the Frick Building (Union Trust Building) at the corner of Fifth Avenue and Grant Street being cleaned and restored to its original condition in June 1951. (Carnegie Library of Pittsburgh.)

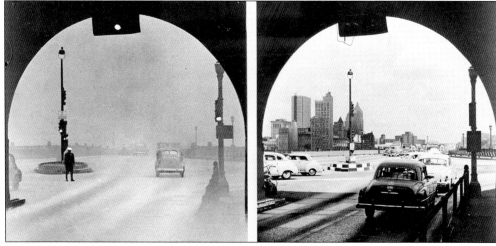

Since smoke control became effective in Pittsburgh in the early 1950s, building owners spent more than $2.5 million in erasing over a century of grime and smoke from city buildings. This view from the Liberty Tunnels looking into the city contrasts the skyline before and after smoke control. Through strong leadership, hard work, and tough resiliency, Pittsburgh had overcome another considerable challenge. (Carnegie Library of Pittsburgh.)

Nine

PROMINENT PITTSBURGHERS

While immigrants were laboring in the factories to build Pittsburgh into the Workplace of the World, other Pittsburghers were becoming famous worldwide, and no one was as celebrated as Andrew Carnegie. In 1848, at the age of 12, he arrived in Pittsburgh with his parents, Will and Margaret, and younger brother Tom. The family had fled the potato famine in Ireland. They rented a small house on Reedsdale Street in the North Side. Andrew's first employment was as a bobbin boy in a weaving mill, six days per week, 12 hours per day, for a salary of $1.20 per week. Soon he was a delivery boy for a telegraph company in downtown Pittsburgh where he developed Morse code skills and began working for Thomas Scott, a manager for the Pennsylvania Railroad, who got him started in business. Here Andrew and Louise say farewell to Pittsburgh on their last visit to the city in 1915. (Carnegie Library of Pittsburgh.)

Andrew Carnegie (right, at 16) and his younger brother Thomas were born into a family that championed the rights of the working class. Yet his obsession with keeping costs down kept him at odds with his own workers. In 1892, Carnegie conspired with Henry Clay Frick to hire Pinkerton agents to run the unions out of the Carnegie Works. In an all-day battle, three Pinkerton agents and seven workers were killed. (Carnegie Library of Pittsburgh.)

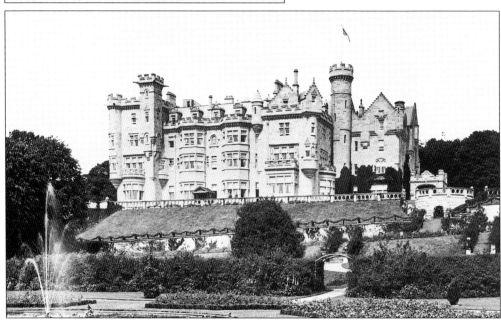

Carnegie bought the 13th-century Skibo Castle in the Scottish Highlands as a retirement home in 1898 for $80 million in today's currency. Carnegie was the wealthiest man in the world, worth over $112 billion by today's standards. He gave much of his fortune away and funded over 2,800 public libraries. "I chose free libraries as the best agencies for improving the masses of people because they (libraries) only help those who help themselves." (Carnegie Library of Pittsburgh.)

Benjamin Franklin Jones (1824–1903) began his career as a clerk with Samuel Kier's canal boat company. In 1853, with Kier's help, he became a part owner of the American Iron Works, which became the Jones and Laughlin Company. The company prospered by supplying iron to the Union army during the Civil War. The Jones and Laughlin Company made iron rails during the railroad boom and became one of the most successful companies in the world. (Carnegie Library of Pittsburgh.)

James Laughlin (1806–1882) immigrated with his family from Ireland to Pittsburgh in 1829. He become a prominent Pittsburgh banker, and in 1852, became president of the Fifth Avenue Savings Bank. He had a perceptive interest in the iron-making business, and in 1856, a partnership with B. F. Jones in the American Iron Works led to the founding of the Jones and Laughlin Company in 1861. (Carnegie Library of Pittsburgh.)

Henry Clay Frick (1849–1919) was born in West Overton. At age 21 he formed Frick and Company with two cousins and a friend. The business used beehive ovens to turn coal into coke, which was used to make steel. He was a millionaire by the age of 30. In 1881, he met Andrew Carnegie. Despite a tumultuous relationship, the two helped each other earn immense fortunes. (Carnegie Library of Pittsburgh.)

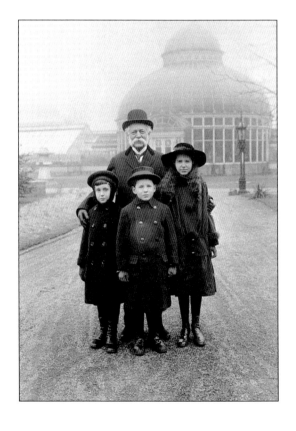

At the age of six, Henry John Heinz (1844–1919), the son of a German brick maker, sold horseradishes that he grew in his tiny garden. Business grew, and by 1869, the Heinz Noble and Company was founded. It became the H. J. Heinz Company in 1905. The company became famous worldwide, manufacturing over 200 products and employing over 2,900 workers. Heinz and his grandchildren pose in front of Phipps Conservatory. (Carnegie Library of Pittsburgh.)

Standing to the right, Edgar J. Kaufmann (1885–1955), seen here with Albert Einstein, was a descendent of Jewish German immigrants Jacob and Isaac Kaufmann who opened a small tailoring business in 1871 that grew into a department store dynasty on Smithfield Street. He was one of the key figures in Pittsburgh's rebirth and wanted to make it "the best city in the America." His home, known as Fallingwater, was designed by Frank Lloyd Wright. (Carnegie Library of Pittsburgh.)

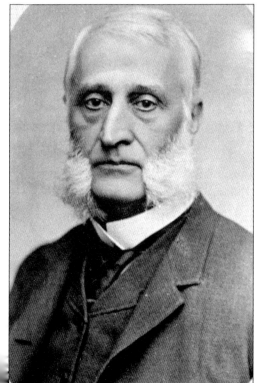

Joseph Horne was born on a Bedford County farm in 1826. He began his merchandising career at age 17 as a clerk. He came to Pittsburgh in 1847 and two years later was sole owner of a store. The *Daily Gazette* announced, "J. Horne, Trimmings, Notions, Millinery and Fancy Goods, opened for business on #63 Market Street." In January 1871, he moved the Joseph Horne Company Department Store into Liberty Hall on Penn Avenue. (Carnegie Library of Pittsburgh.)

Elizabeth Cochran (1864–1922) took her pen name from Stephen Foster's song "Nellie Bly." She was a journalist for the *Pittsburgh Dispatch*. In 1890, the 22 year old became a national celebrity when she completed a trip around the world in 72 days, a week less than the journey of Jules Verne's fictional hero Phileas Fogg in the book *Around the World in 80 Days*, published in 1873. (Carnegie Library of Pittsburgh.)

Biologist Rachel Carson (1907–1964) showed an early concern for the price of living in a chemical environment in her best-selling book *Silent Spring*. Carson asked, "Why should a poison, dust or spray, however greatly it may advantage a grower . . . enjoy immunity while there is any reason to suspect that it may endanger the public health or damage the natural scene?" She was responsible for the banning of the insecticide DDT. (Carnegie Library of Pittsburgh.)

Stephen Collins Foster was born in Pittsburgh on July 4, 1826. He published his first song when he was 18 years old. He wrote over 200 songs, including such American sing-a-long favorites as "Oh! Susannah," "My Old Kentucky Home," "Camptown Races," "Jennie with the Light Brown Hair," and "Old Folks at Home." He died in New York City on September 13, 1864. (Carnegie Library of Pittsburgh.)

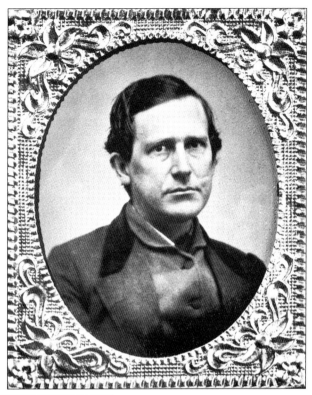

John Kane was one of Pittsburgh's most important artists along with Mary Cassatt and Andy Warhol. He was a laborer, lumber cutter, and gandy dancer pounding railroad ties into place. He immigrated to Pittsburgh from Scotland in 1879 and painted only in his spare time. His primitive artwork was first recognized in 1927 at the Carnegie International when he was 67 years old. (Carnegie Library of Pittsburgh.)

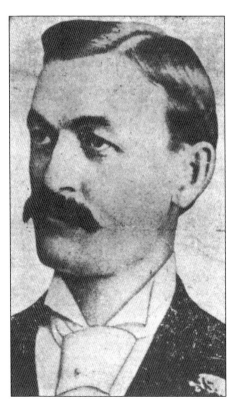

The Ferris wheel was invented by George Ferris, a Pittsburgh bridge builder. It was designed for the Chicago world's fair in 1893 as a rival to the Eiffel Tower in Paris. In 19 weeks, the big wheel attracted 1,453,611 riders who paid a record $726,805 to ride in its circular glass enclosures. The wheel was supported by two 140-foot steel towers connected to a 45-foot axle. (Carnegie Library of Pittsburgh.)

Robert Vann (1879–1940) came to Pittsburgh in 1930 to attend the University of Pittsburgh. He graduated with a law degree in 1909 and was one of the founders and the editor of the *Pittsburgh Courier* until his death in 1940. From 1917 to 1931, he was the assistant city solicitor of Pittsburgh and in 1933 was named special assistant attorney general of America by Pres. Theodore Roosevelt. (Carnegie Library of Pittsburgh.)

Josie Carey and her husband, Henry Massucci, open fan mail from the *Children's Corner* program. Fred Rogers (1928–2003) is seated in the background. Rogers joined WQED, Americas first publicly owned television station, as a program director in 1953. In April 1954, he collaborated with Carey on scripts and music to produce the *Children's Corner*, which won the 1955 Sylvania Award for the best locally produced children's program in the United States. (Historical Society of Western Pennsylvania.)

Francois Clemmons, seen at the piano, is giving Rogers and Mr. and Mrs. McFeely a singing lesson at his music studio on the children's television show *Mr. Rogers Neighborhood*, which first aired in 1968. The daily program was produced at WQED and syndicated nationally on the Public Broadcasting Service (PBS). It was the longest-running program on PBS, producing over 900 episodes and reaching eight million children each week. (Historical Society of Western Pennsylvania.)

Shown here in his laboratory in 1921, Dr. Frank Conrad, a Westinghouse engineer, began experimenting with a wireless telephone in 1916 that led to an amateur radio station in a garage behind his house. This is where KDKA had its birth as the first radio station in the world. The first broadcast was the Warren G. Harding versus James M. Cox presidential election returns on November 2, 1920. (Carnegie Library of Pittsburgh.)

Dr. Jonas Salk is in the Virus Research Laboratory of the School of Medicine at Pittsburgh University in March 1954. Salk developed a serum to combat infantile polio paralysis. He gave his first inoculation to 137 children at Arsenal School in Lawrenceville on February 23, 1954. On April 4, 1955, he announced a vaccine that virtually wiped out polio epidemics among young children. (Carnegie Library of Pittsburgh.)

The Pittsburgh Crawfords baseball team poses on the steps of the Carnegie Library in the Hill District. This team was the cornerstone of the Negro National League in 1933, featuring Satchel Paige, Cool Papa Bell, Josh Gibson, and Judy Johnson. The team was owned by Gus Greenlee, who built Greenlee Park for the team. Paige was on the mound for the park's first game on April 29, 1932. (Carnegie Library of Pittsburgh.)

Dr. John Bain "Jock" Sutherland (1889–1948) played for the University of Pittsburgh Panthers in 1915. He coached the Panthers from 1924 to 1938 and was known for the single-wing "one yard and a cloud of dust" running game. He then coached the Pittsburgh Steelers. Owner Art Rooney said, "He gave Pittsburgh fans the kind of teams they were looking for. If it hadn't been for the Doctor I never would have been able to continue in pro football." (Archives Service Center of the University of Pittsburgh.)

Pittsburgh was a boxing town. Fritzie Zivic (1913–1984), here with his 14-month-old son, became the welterweight champion of the world from 1940 to 1941. The son of a Croatian immigrant, he and his five brothers were known as the Fighting Zivics. Zivic once said, "You either had to fight or stay in the house. We went out." He was known for his classic fights with Henry "Hammering Hank" Armstrong. (Carnegie Library of Pittsburgh.)

Billy Conn (1917–1993) was the light heavyweight champion of the world from 1939 to 1941. In June 18, 1940, he fought Joe Louis (left) for the heavyweight championship of the world at Madison Square Garden. He had a secure lead until the 13th round when he foolishly decided to go for a knockout. Instead Louis knocked Conn out with a hard right to the jaw. (Historical Society of Western Pennsylvania.)

Tony "TD" Dorsett was a Heisman Trophy candidate during his years as a tailback for the University of Pittsburgh Panthers from 1972 to 1976. He won the award in his senior year. In his 11-year career with the Dallas Cowboys and Denver Broncos, he rushed for 12,739 yards and scored 77 touchdowns. He was elected into the NFL Hall of Fame in 1994. (Archives Service Center of the University of Pittsburgh.)

Coaches Jackie Sherrill and Joe Pendry talk to quarterback Dan Marino, who led the University of Pittsburgh to four consecutive top-10 poll finishes from 1979 to 1982. He played professional football with the Miami Dolphins. He retired in 2000 and was inducted into the NFL Hall of Fame in 2005. Marino holds or has held almost every NFL passing record and is recognized as one of the greatest quarterbacks in football history. (Archives Service Center of the University of Pittsburgh.)

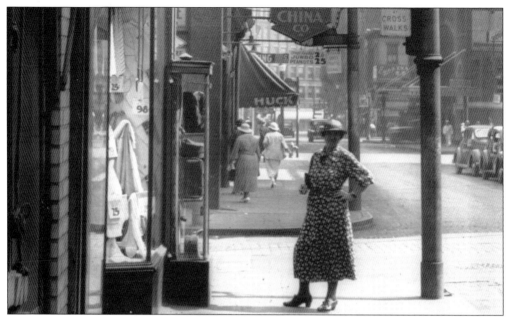

A woman in front of the Il Duce Restaurant at 3317 Market Street on July 12, 1936, symbolizes the women who raised the families who built Pittsburgh. Paul Kellog wrote in 1908 that Pittsburgh is "the capital of a district representative of untrammeled industrial development . . . a district which, for richer, for poorer, in sickness and in health, for vigor, waste and optimism, is rampantly American." (Archives Service Center of the University of Pittsburgh.)

Two Pittsburgh men converse in 1950. They represent the people who developed a spirit of pride in Pittsburgh and its people. Pittsburghers love their town and its heritage. They believe in a "fair days work for a fair day's wages." (Carnegie Museum of Art.)

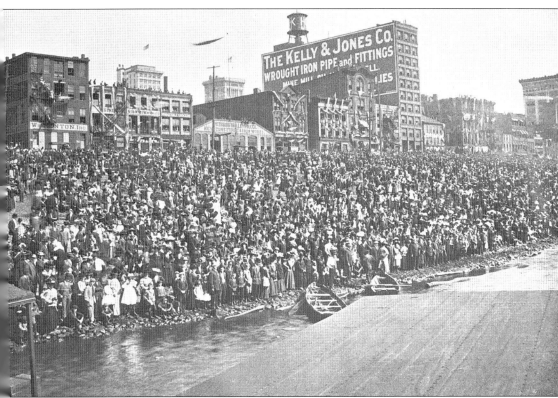

A crowd of over 300,000 people gathered on the Mon Wharf in 1908 to celebrate the 150th anniversary of the city of Pittsburgh. In 1920, Fredrick Law Olmsted Jr., professor of landscape architecture at Harvard University, wrote about Pittsburgh, "Here is a spot where the Ohio River has its birth: here was built the fort which broke the peace of Europe and around which turned the frontier struggles of the war that gave America to the English-speaking race . . . Poetically, this spot, at the meeting of the rivers, stands for Pittsburgh . . . It seems to be rather forgotten and disregarded by most Pittsburghers. But its historical and topographical significance can never be altered and it is to be hoped that the City will rise to its opportunity and nobly form the Point into a great monument." By Pittsburgh's 250th anniversary in 2008, Olmsted's vision had been fulfilled. The small wedge of land at the Forks of the Ohio where 21-year-old Col. George Washington first set foot in 1753 had become the city where history was changed and America was built. (Carnegie Library of Pittsburgh.)